Organize Your

Home

...In No Time

Debbie Stanley

que®

800 East 96th Street,
Indianapolis, Indiana 46290

D1378581

Organize Your Home In No Time

International Standard Book Number: 0-7897-3371-4

Library of Congress Catalog Card Number: 2004117325

Printed in the United States of America

First Printing: August 2005

08 07 06 05 4 3 2 1

Trademarks

All terms mentioned in this book that are known to be trademarks or service marks have been appropriately capitalized. Que Publishing cannot attest to the accuracy of this information. Use of a term in this book should not be regarded as affecting the validity of any trademark or service mark.

Warning and Disclaimer

Every effort has been made to make this book as complete and as accurate as possible, but no warranty or fitness is implied. The information provided is on an "as is" basis. The author and the publisher shall have neither liability nor responsibility to any person or entity with respect to any loss or damages arising from the information contained in this book.

Bulk Sales

Que Publishing offers excellent discounts on this book when ordered in quantity for bulk purchases or special sales. For more information, please contact

U.S. Corporate and Government Sales
1-800-382-3419
corpsales@pearsontechgroup.com

For sales outside of the U.S., please contact

International Sales
international@pearsoned.com

Executive Editor
Candace Hall

Development Editor
Lorna Gentry

Managing Editor
Charlotte Clapp

Project Editor
George E. Nedeff

Production Editor
Benjamin Berg

Indexer
Aaron Black

Technical Editor
Ann Gambrell

Publishing Coordinator
Cindy Teeters

Multimedia Developer
Dan Scherf

Interior Designer
Ann Jones

Cover Designer
Ann Jones

Cover Illustrator
Nathan Clement, Stickman Studio

Page Layout
Nonie Ratcliff

Organize Your **Home** ...In No Time

Contents at a Glance

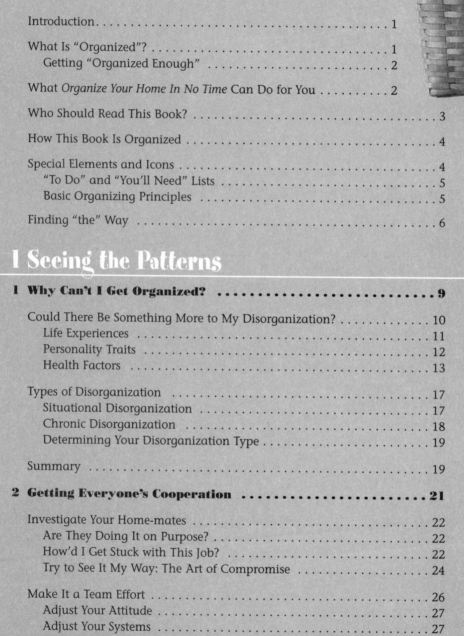

Table of Contents

I Seeing the Patterns

III Maintaining Your Progress

IV Appendix

About the Author

Debbie Stanley transitioned from a successful career in journalism and reference publishing to the highly rewarding role of professional organizer and coach for chronically disorganized clients. As the owner of Red Letter Day Professional Organizers (www.RLDPO.com), Stanley's work is informed by a bachelor's degree in journalism and a master's degree in industrial/organizational psychology. Stanley contributes to the growth of her industry as a trainer for fellow organizers and as a speaker to groups including Children and Adults with Attention Deficit/Hyperactivity Disorder (CHADD). She is the chair of the National Association of Professional Organizers (NAPO) Publications Committee and president of NAPO's Southeast Michigan Chapter. Stanley is also a past board member of and active participant in the National Study Group on Chronic Disorganization (NSGCD) and has earned the NSGCD Chronic Disorganization Specialist and ADD Specialist certificates.

Dedication

To Steve and Kyle, as we begin organizing our home together.

Acknowledgments

I'm indebted to so many people for their help with this book!

Thanks to my clients, who have taught me as much as I've taught them. I love my work because of you!

Thanks to my colleagues, including Barry Izsak, Jennifer McDaniel, Val Sgro, Sheila Delson, Terry Prince, K. J. McCorry, Monica Ricci, Diane Hatcher, Heidi Schulz, my fellow NAPO-Southeast Michigan chapter members, and Ann Gambrell, my technical editor for this book and an icon of professional organizing. Your cheerleading kept me going when the going got tough.

Thanks to my family and friends for relinquishing the time and energy I took from them to give to this book. You trusted that one day I would leave the office long enough to actually shut off the lights and computer, and that day has finally arrived.

Thanks to my Que team, especially Candy Hall, George Nedeff, Lorna Gentry, and Ben Berg for their editorial expertise, and Kim Herbert and Andrea Bledsoe for their promotional wizardry. You're all delightful to work with and I appreciate your commitment to helping me do my best work.

We Want to Hear from You!

As the reader of this book, *you* are our most important critic and commentator. We value your opinion and want to know what we're doing right, what we could do better, what areas you'd like to see us publish in, and any other words of wisdom you're willing to pass our way.

As an executive editor for Que Publishing, I welcome your comments. You can email or write me directly to let me know what you did or didn't like about this book—as well as what we can do to make our books better.

Please note that I cannot help you with technical problems related to the topic of this book. We do have a User Services group, however, where I will forward specific technical questions related to the book.

When you write, please be sure to include this book's title and author as well as your name, email address, and phone number. I will carefully review your comments and share them with the author and editors who worked on the book.

Email: feedback@quepublishing.com

Mail: Candace Hall
 Executive Editor
 Que Publishing
 800 East 96th Street
 Indianapolis, IN 46240 USA

For more information about this book or another Que Publishing title, visit our website at www.quepublishing.com. Type the ISBN (excluding hyphens) or the title of a book in the Search field to find the page you're looking for.

Introduction

"**I** have GOT to get organized!"

Seems like everyone has said that at least once, and some say it at least once a day. But when you start thinking about actually doing it, getting organized can seem like more trouble than it's worth. Who has the time to color-coordinate their clothes and alphabetize their CDs? What real-life household looks like those pretty magazine photos, and really, who'd want it to? Why would you spend a weekend "organizing" (whatever that means, exactly) when you could be relaxing, spending time with family and friends, or catching up on more urgent projects? Why, come to think of it, is it so all-fire important to be organized anyway?

What Is "Organized"?

The first thing we need is a realistic definition of "organized." An organized space is not necessarily

- Perfect
- Trouble-free
- Easy
- Maintenance-free
- Beautiful
- Empty
- Expensive

An organized space IS always

- Functional

It can be beautiful as well, but it doesn't have to be. It can be perfect as in optimal, but not perfect as in unattainable, and certainly not fussy and high-maintenance. A space doesn't have to be devoid of objects in order to be organized, although it will probably seem much more spacious.

You can spend lots of money on organizing tools if you want to, but you don't have to. In fact, your organized space will save you money by preventing you from having to buy duplicates of things you lost or replacing things that got ruined because they weren't stored properly. Getting organized will also save you time in the long run: You will have to invest a chunk of time in the beginning and smaller bits thereafter to maintain your level of organization, but it will be less time than you lose searching for things.

Getting "Organized Enough"

I advocate being "organized enough." When you're organized enough, you almost always reach destinations and complete tasks and projects on time, and you don't forget very many things you meant to remember. In your organized home, the focus of this book, you can put anything away when you want to and you can find pretty much anything on the first try.

When you're organized, things will still go wrong in your life, but at least disorganization won't be one of the contributing factors. The basement might still flood, but if the stuff down there is stored in water-resistant containers, the damage will be minimized. And, every once in a while, you'll forget something or lose something or be late to an appointment, but it won't happen very often. To completely eradicate these occasional lapses would require being more than organized enough, and it's not worth it. Organized enough means you are functioning at a level that is both productive and maintainable in the long term. I express this goal to my clients by reminding them that it's possible—and perfectly acceptable—to get an "A" without getting 100 percent.

What *Organize Your Home In No Time* Can Do for You

The *In No Time* series was created for busy people who want to enhance areas of their lives that could use some organization. The title has two meanings: You want to get organized very quickly (seemingly in no time) and you need to accomplish this feat in the absence of spare time on your part (you have "no time" to organize). Getting organized won't necessarily be easy, and it won't happen overnight, but I

promise it will be well worth it: Once you're organized, everything else becomes easier. Complete each of the projects in this book and you will

- Identify the causes of your disorganization, both within yourself and as a result of others in your space
- Gain new ideas for getting other household members to embrace and cooperate with your organizing systems
- Learn principles that will serve as a foundation for adding organization to any area of your home, and even any area of your life
- Assess and defeat your clutter patterns
- Take an organized approach to purging clutter from every area of your home
- Implement storage options that work best for your home and family
- Learn to detach from belongings that are not supporting you
- Maintain your progress over time and recover from occasional (and inevitable) setbacks
- Put safety measures in place to prevent clutter from creeping back

Who Should Read This Book?

If you believe you are capable of organizing your home but you need some guidance and encouragement, you've come to the right place. This book is meant for readers who

- Enjoy being organized and are willing to put forth the effort to achieve that state
- Have been organized in the past but have experienced a new challenge or situation that has brought disorganization into their lives
- Want to put new systems in place but don't want to create them from scratch
- Are struggling to adapt to a life transition, such as the birth of a child, a job change, or a divorce, which can wreak havoc with previously established organizing systems
- Are establishing their first households or have been given the responsibility of household management for the first time
- Have already established pockets of organization but would like to improve or build upon them
- Are frustrated by the negative impact of disorganization in their homes and are ready to work toward positive change

For some people, this book will be a great start, but it won't be the only help you need. If you are intimidated by organizing or have had little success with past organizing efforts, you might find it most beneficial to work through this book with the guidance of a professional organizer—preferably one with experience in chronic disorganization. If you have attention deficit/hyperactivity disorder (AD/HD), it's important that you recognize its impact on your organizing abilities: Give yourself permission to be not so good at this and accept assistance from family, friends, an AD/HD coach, and your medical doctor or therapist.

How This Book Is Organized

The lessons and projects in this book are presented in a logical sequence, so you will have a more seamless experience if you work through the book from beginning to end. However, if you prefer you can use portions of the book in random order—especially if you're already organized in some of these areas and simply want to fill in the gaps in your system.

This book is organized into three parts; here's what each contains:

- In Part I, "Seeing the Patterns," you'll begin by identifying the reasons disorganization has been a problem for you. Understanding where the difficulty comes from is half the battle; from there, you can begin to strategize and put improvements in place with a targeted and efficient approach. This section will also give you insight into whether external forces (other family members, for example) are making it difficult for you to apply the organization you want. With that insight, we move into the organizing principles that will serve as the foundation for the rest of your progress in this book and beyond.

- In Part II, "Clearing the Clutter," you'll organize your attack, then roll up your sleeves and start purging clutter. You'll learn the most effective ways to create storage for the items that have earned the right to remain in your home, and you'll also find help and encouragement for times when the going gets tough.

- In Part III, "Maintaining Your Progress," you'll learn how to maintain your organization over time and settle into a more organized lifestyle. This section also contains information on handling special situations such as holidays, house guests, and preparing to sell your home, plus a step-by-step plan for getting back on track when it seems like everything has fallen apart (what we organizers call "backsliding").

Special Elements and Icons

Throughout this book, you'll find a variety of special elements—lists, sidebars, icons, and other "extras" designed to catch your eye and call out items of special interest

relevant to the nearby text. Some of these special elements are described here to help you learn how to use their information when you encounter them in your reading.

"To Do" and "You'll Need" Lists

Each chapter of the book includes a list of what you'll need and one or more to-do lists. "You'll Need" lists give you a quick reference for organizing equipment and supplies and, if necessary, shopping: Be sure you have these items on hand before you begin so you can make the most of your organizing time. The items on your "To Do" lists give you the steps you'll take to complete the projects in each section.

Basic Organizing Principles

There are a few organizing principles that I think of as the foundations of what I do as a professional organizer. One or more of these principles comes into play with every job I take, and each of my clients becomes accustomed to hearing me mention them again and again. Because these ideas are so important, I've flagged examples of them throughout the book with the icons you see here. If you read my earlier book, *Organize Your Personal Finances In No Time*, you'll be familiar with these icons; the principles behind them are the same as those I presented there. Absorb these key principles into your approach to organizing your home, and then use them in other areas of your life and see what a difference they'll make for you:

Have a Home: Designate a "home" for every item you own, including all types of paper. A major component of clutter management is knowing where to put things when you're ready to put them away. Not everything has to be in its home all the time, just as long as it has a space reserved for it and can go there any time.

Be Consistent: Do things the same way each time. Invest in creating a method that you can easily develop into productive habits, and avoid reinventing the wheel each time.

Use Your System: A system works only if you apply it comprehensively and consistently. If the process isn't working, modify it to meet your needs or even switch to something completely different, but don't abandon the project altogether. Being organized will always require some effort on your part, but it should be like a merry-go-round: You have to pull hard and run with it to get it going, but once it has momentum, you can just stand still and give it a regularly scheduled push.

Organized Enough: Be only as organized as you have to be. Avoid organizing for its own sake. Organizing is not something that has inherent value, like kindness, for example. Kindness is a good thing to practice even if it provides no direct benefit for you. Organizing, on the other hand, is a tool that should be used only for a reason: Organize your pantry to save yourself time and frustration in the future, not just to

put its contents in a different order. If your clothes are hung facing left, don't take the time to make them face right just because. When you're organized enough, stop.

Finding "the" Way

"This is my way. What is your way? THE way does not exist."—Friedrich Nietzsche

I made this point in *Organize Your Personal Finances In No Time*, and it's relevant in this book as well: In organizing, as in life, there is always more than one right way. This can be frustrating if you're tired of trying to choose and simply want someone to show you the way so you can embrace it without second-guessing. In this book, I present you with just one or a few options—the ones I have found to be the most useful, easiest, or most popular with my clients—and invite you to apply all of my techniques as-is or to modify them as you wish. I encourage you to find your own ideal balance between the time invested and the usefulness of the end result—your unique version of "organized enough."

Part I

Seeing the Patterns

Why Can't I Get Organized?

1

or some folks, being organized comes naturally. It's such a basic part of them that they often don't realize organization is an ability that not everyone has. They figure (or would figure, if they gave it conscious thought) that anyone who is disorganized is just not making an effort, and his or her judgmental attitude comes through loud and clear. Like a slim person telling an overweight person to "just eat less," this combination of superiority and ignorance makes many innately organized people insufferable.

Organizing is both an inherent ability and a learned skill. You might be born with it, but if not, you can learn it. The extent to which you can learn it depends on a lot of things, many of which are introduced in this chapter, but everyone is capable of improving their level of organization. People who are born with an aptitude for organizing just have a head start.

If you're reading this book to help yourself, you're probably not one of those "born organized" folks. That's fine—at least you're not going around making everyone else feel inadequate! Here's your first—and most important—lesson of this book:

1. Not everyone has natural organizing ability, so stop searching yourself for something you think must be there if you could only find it. (Yes, just like your car keys.)

2. People with natural organizing ability are no better than you.

3. There is nothing wrong with you for not knowing how to do this.

Bottom line: Disorganization is just a problem to be solved; it is not a character flaw. (Many people cry when I tell them that, so if you're feeling a little teary right now, you're in good company.)

Let's look at disorganization as the solvable problem that it is. In the next section, I present a number of factors that contribute to disorganization. You might recognize yourself or a loved one here, and that realization might pave the way for you to find your own unique solutions within the chapters to come. However, there are a lot of issues listed here that call for the assistance of a medical or mental health professional, so if you know or suspect that you or a loved one has one or more of these conditions, please don't neglect to get that extra help.

CAUTION! RESPECT THEIR BOUNDARIES

If you are reading this book for ideas to help someone else, I commend you, but I also caution you to be careful not to force your ideas on the other person. You certainly have the authority to decide what is best for yourself, and if, in reading the information on possible causes of disorganization, you find a condition that you think could be your problem, you have the authority—and I strongly encourage you—to talk to a doctor or therapist to confirm or rule out that condition. Just remember that with another person, you can suggest but you can't demand, and no matter what, you can't diagnose.

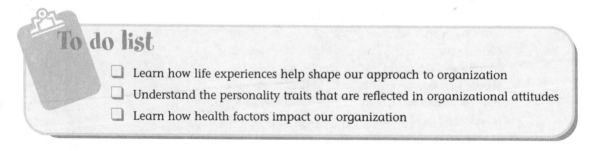

To do list

- [] Learn how life experiences help shape our approach to organization
- [] Understand the personality traits that are reflected in organizational attitudes
- [] Learn how health factors impact our organization

Could There Be Something More to My Disorganization?

In a word, absolutely. There are many life experiences, personality traits, and health factors that can result in mild to severe disorganization. I have found that becoming aware of these conditions is half the battle toward diluting their impact, so, for your

enlightenment before we dive into decluttering your home, in this section I offer an overview of the most common causes of disorganization.

"Disorganization is just a problem to be solved; it is not a character flaw."

Life Experiences

How was your childhood, organizationally? Did you grow up in a home where everything was always neat and tidy? Or was it more like a nest lined with bits of this and pieces of that on the floors and countertops? Either way, you might have mimicked your childhood surroundings as you established your own home in adulthood, or you might have rebelled and created a home that is the very opposite of the one in which you grew up.

Every child feels embarrassed of his or her home at some point, rationally or not, but were you ever ashamed to bring friends home because the house was too messy? Or, on the flip side, did you hesitate to invite people over because the house was a showplace and you would be in trouble if anything got messed up? Either of these situations might very well impact how you feel about keeping your home organized today.

Looking back, would you say your parents were organized, or not? What about their tendencies toward acquiring and owning things—did they believe in stocking up on food and household supplies? Did they use money in a controlled manner, spending and saving according to a plan, or did they seem to go through peaks and valleys of expansive spending followed by weeks of being "broke"? Were you aware of your parents living paycheck-to-paycheck, or did their money not enter your consciousness very much? Any of these points might have something to do with your current attitudes toward money, belongings, and the volume of household supplies you need to have in stock in order to feel comfortable.

Many people don't realize just how much of an impact their childhood circumstances can have on their adult household management tendencies and abilities. Once these connections are identified, organization-related problems can sometimes melt away: Simply becoming aware of the reasons behind your inclination to save every cardboard carton (and, in the process, use up your valuable storage space) can help you rationalize and get past this counterproductive habit.

note Childhood trauma that results in adult disorganization can be painful to identify and process. When this happens with a client, I explain that it's very common for our organizing to dredge up tender issues, and that many people find it helpful to work with a therapist at the same time. The therapist can then support the client in dealing with emotions that could be triggered as we continue moving forward with our organizing projects.

Personality Traits

Childhood experiences, including those mentioned previously, shape our personality in later life. There are also certain personality traits that can interfere with your organizing goals and abilities. These traits are significant because they are deep-rooted and are closely linked to the person's sense of self-worth. Here are three of the most problematic, organization-encumbering personality traits:

Acquisitiveness

Acquisitiveness is a more diplomatic term for what is commonly called *compulsive shopping* or *shopaholism*. It is the tendency to acquire things at a rate or quantity that is unmanageable organizationally. Simply put, acquisitive folks tend to own more stuff than they have space for.

If you often have shopping bags lying around with the purchases still in them because you don't know where to put them or you haven't had time to put them away, and/or if you consider shopping a hobby and you do it as a stress reliever, you might have a problem with acquisitiveness. At an extreme level, acquisitiveness becomes not just a personality trait but a form of mental illness.

Perfectionism

We all know what *perfectionism* means—being unwilling to do something unless you can do it absolutely perfectly. Sometimes people don't realize they're harboring perfectionist tendencies. Think about it: How do you feel about the phrase "good enough"? Do you consider it appropriate at times, or does it equate with "lazy" or "halfway job"?

If you don't see room in your life for some "good enough," you're likely to have trouble getting organized. Ironically, many people think "organized" means "perfect," but it doesn't. Perfectionism is not conducive to organization—in fact, it's a major hindrance.

Poverty Mentality

Poverty or *deprivation mentality* means that you always feel you should get things while you can, in bulk, because you might not be able to get them when you need to. It causes you to keep things just in case you need them later, even if you don't foresee that need arising. It causes you to keep anything that could be useful in some way, even if you don't have a need for it right now and, indeed, never have.

If you've ever lived on a shoestring budget and know what it's like to not be able to afford a four-pack of toilet paper, it would come as no surprise to me if you now buy toilet paper in 96-roll pallets at the warehouse club. If you love trolling your neighborhood garage sales because you can buy perfectly useful (but, honestly, unneeded) things for cheap, you might have a poverty or deprivation mindset.

With my clients, simply making them aware of this phenomenon is often enough to overcome it. Once they realize that life is now stable and toilet paper will always be available, four or eight rolls at a time, they let go of the need to stockpile. If this sounds like it might be you, let the idea incubate for a while and see if your philosophy toward buying in bulk starts to change.

note Poverty mentality looks a lot like frugality, a generally admired trait in our society. If frugality is your purpose for buying in bulk and you have a true need for the items, the time to compare prices, and the space to store the stockpile, go for it. But consider the possibility that your motivation is actually something other than healthy frugality and that this behavior might be complicating your efforts to get organized.

Health Factors

If you've been lucky enough to escape the childhood experiences and personality traits that can lead to a disorganized life, you're not out of the woods yet: There are also physical health factors that can keep you from getting and staying organized. Some affect your ability to concentrate, think clearly, or sustain interest and enthusiasm for tasks; some drain your energy so much that you barely have enough for life's requirements, so organizing is always on the back burner; and some limit your body's movement and strength, meaning you can't lift containers or pick up clutter from the floor.

These conditions are problematic enough when you're aware of them, but if left undiagnosed—as is often the case with AD/HD and traumatic brain injury—their negative impact is far greater. If something in your body is preventing you from being organized, but you don't know that's the cause, you will likely believe it's "your own fault" and conclude that your work ethic, ambition, or worth as a person is lacking. From there, your self-esteem will suffer, and you'll be even less likely to succeed at organizing!

If you have even the slightest suspicion that there might be a physical condition preventing you from getting organized, have it checked out.

AD/HD and Learning Disabilities

The most common cause of chronic disorganization that I see among my clients is *attention-deficit/hyperactivity disorder*, or *AD/HD*. The three main characteristics of AD/HD are hyperactivity, distractibility, and impulsivity; not everyone with AD/HD has all three, but each of these characteristics is incompatible with the essential but often boring and repetitive tasks of an organized lifestyle. The result is that disorganization is a hallmark of life with AD/HD.

Folks with AD/HD also tend to be more easily overwhelmed—kind of like a touchy circuit breaker that shuts down at the slightest surge. Because of this, complex or time-consuming projects are especially challenging, and the need to dig out from a

backlog of clutter and paper piles can send an AD/HDer into a spiral of panic, avoidance, and shame. Research has also shown that people with AD/HD are more likely to have a coexisting learning disability such as dyslexia.

As awareness of AD/HD grows, many people are being diagnosed in adulthood—often after their children have been diagnosed with AD/HD and the family begins to learn about the inherited nature of the condition. A diagnosis of AD/HD can be highly traumatic for an adult who has spent his or her life feeling ashamed of the inadequacies for which AD/HDers must learn to compensate. Professional organizers and AD/HD coaches are often called upon to help newly diagnosed adults learn to function optimally with AD/HD, and organizing tasks including time, paper, and clutter management are usually central to this education.

ADULTS HAVE AD/HD TOO!

AD/HD is not just a childhood disorder, as was once believed. Experts now recognize AD/HD as a neurobiological disorder that affects people throughout their lives. The National Resource Center on AD/HD, a division of Children and Adults with Attention Deficit/Hyperactivity Disorder (CHADD), reports that an estimated 2 to 4 percent of the adult population has AD/HD, which is thought to be inherited because it tends to run in families.

If you suspect you or your child might have AD/HD, it is imperative that you talk to a qualified professional who is experienced in diagnosing AD/HD. For more information, visit www.CHADD.org.

Obsessive Compulsive Disorder

Obsessive compulsive disorder (OCD) is sometimes a contributing factor in disorganization. OCD manifests in different ways from person to person, but when it includes obsessively perfectionist thoughts or compulsive checking behaviors, it can result in severe disorganization.

One woman living with OCD explained that she could not bring herself to throw anything away because it might contain something important. For example, she could not part with a balled-up cheeseburger wrapper because she was afraid she might have inadvertently wadded up some money inside the wrapper. A person without OCD would probably not have this concern in the first place, knowing that she would never put cash inside a used food wrapper, but if she did think it might have happened, she would simply open up the wrapper, see that there is no money there, and throw it away. An untreated OCD sufferer would not be satisfied with checking once: She would be unable to trust that she had checked completely or enough, no matter how many times, and would still be unable to part with the wrapper.

Another behavior that impacts organization is hoarding. *Hoarding* is sometimes diagnosed as a form of OCD, and sometimes it is mild enough not to warrant a diagnosis but significant enough to interfere with organizing. Organizationally, the basic problem with hoarding is that there is never enough space to store everything the person wants to keep. A hoarder is reluctant or will even outright refuse to let go of anything, even if the object is of no use (that cheeseburger wrapper, for example)—which is why the last person a hoarder wants to deal with is a professional organizer, even an empathetic one.

Depression

Depression is very common among chronically disorganized people. In fact, depression and disorganization seem to feed one another: Depression often leads to disorganization, and disorganization reinforces the hopeless feelings of depression.

caution Living with a hoarder can compel you to take drastic action, but no matter what, do not throw away their stuff without permission!

People with hoarders in their lives are often tempted to trick the person into getting rid of stuff. The family might decide to send Mom on a weeklong vacation, then pull up a dumpster and empty out her house while she's gone. This is NEVER a good idea! It is psychologically devastating to hoarders to have their belongings taken from them, even the stuff that is truly trash. NEVER DO THIS! Instead, work with a mental health professional experienced in OCD and hoarding to determine the best way to help the hoarder.

One of the characteristics of depression is a crushing inability to feel enthused about projects like getting organized. Often it takes everything you've got just to get out of bed or have a meal, so tasks that are not essential to survival become impossible. When you're depressed, you just don't feel optimistic about anything, so you don't see the point of trying to be organized when it's just going to fall apart again anyway.

Depression is not an attitude; it is a medical condition that requires and can be greatly improved by medical attention. Clients sometimes think that if I can just help them to get organized, they won't be depressed. It's true that making progress toward a goal can lift your spirits, but it can't "cure" clinical depression. Treating the depression first will make your organizing progress much faster and easier.

Fatigue- and Pain-Causing Diseases

Many of my clients live with chronic fatigue syndrome, fibromyalgia, rheumatoid arthritis or osteoarthritis, irreparable back injury, or thyroid disorder. These conditions cause exhaustion, chronic pain, or both, which makes life literally a drag.

Sometimes a client has lived with it for so long that he or she doesn't make a direct connection between the condition and the lack of organization. When I point it out—"Well, of course you can't keep up with organizing—you're tired and you hurt,

so why would you want to run around putting stuff away?"—it often comes as a huge epiphany.

If this is your reality, focus on organizational systems that are as efficient and accessible as possible, and be very careful not to take in more belongings than you absolutely need. You have no spare energy for tending to items that are not essential, that are high-maintenance, or that do not contribute greatly to your happiness.

DO YOU HAVE AN "EYE" FOR SPACE?

Can you picture whether something will fit into a space? Can you "eyeball" a measurement accurately or judge whether a picture is hanging straight? This "spatial relations ability" makes organizing much easier because you can envision how a space can function without having to try everything for fit: You can look at a shelf, then go to the store and find a container to fit on that shelf without having to measure each dimension. A large percentage of my clients are lacking in spatial relations ability, and it is often a significant contributor to their disorganization.

Mobility Limitations

In addition to the fatigue- and pain-causing conditions noted previously, anything else that limits mobility will make organizing more difficult. Some mobility limitations are obvious, for example if you are wheelchair-bound, but sometimes people have limited mobility and don't really think of it as such. Do your knees or your back make it uncomfortable to pick things up from the floor? Is your vision impaired to the point that you actually can't see the decluttering that needs to be done? Do you get winded while climbing stairs or bustling around to put things away? You might not realize it, but these factors can prevent you from taking advantage of decluttering opportunities throughout the day, and over time the organizing tasks really pile up.

Brain Injury

The last factor I'll mention is brain injury. Please DON'T SKIP this section, even if you think it doesn't apply to you. Traumatic brain injury, or TBI, is often undiagnosed because the person has no memory of the injury or thinks "a little bump on the head" was no big deal. Even when a head injury is known, the possibility of TBI is often minimized, again because it might seem like a minor incident, and the resulting loss of function can be gradual and subtle.

Most people are unaware of just how much damage can be done with one whack on the ol' melon. A doctor once asked me if I had ever had a concussion and I answered, "Well, of course. Which one do you want to hear about?" He was incredulous: "Which ONE? How many have you had?" I replied, "Oh, about six that I can think of right now—you know, the usual." I wasn't especially accident-prone or rambunctious as a kid, but I played a lot of sports and took a lot of shots to the head, and I had one car accident that really rang my bell.

I was stunned when the doctor told me most people make it through life without even one concussion, and my six (two of which were also skull fractures) are far beyond normal, acceptable, or safe. He alerted me to the possibility that I might experience TBI-related symptoms somewhere down the road, and you can be sure I'll do everything I can to avoid another head injury. That doctor would probably be amazed to know I wrote this book.

If you or someone you know is having trouble with organizing tasks, especially if they used to be better at it, add TBI to the list of possibilities to check out with your doctor.

Finding Help

For more information on the conditions discussed in this section, check out the resources listed at the back of this book. Remember, it is never a good idea to self-diagnose; if you suspect that you or someone in your family has one of these conditions, seek advice from a qualified professional.

To do list

- [] Understand the causes and symptoms of situational disorganization
- [] Learn the signs of chronic disorganization

Types of Disorganization

While you're considering the possible causes of your disorganization, it's also helpful to understand that there are different types of disorganization. Knowing your type can help you choose the most effective remedies.

There are two basic types of disorganization: situational (or temporary) and chronic (or ongoing). The seriousness of the disorganization can range from mild to severe in either type.

Situational Disorganization

Situational disorganization (SD) happens as the result of a life event or set of circumstances. It is a temporary state in which you are less organized than normal

(whatever normal might be for you). Typical SD scenarios include moving to a new home, getting married or divorced, the birth of a child, or switching jobs. Even a new pet, a complex science project carried out on the dining room table, or an extended illness in the household can cause situational disorganization.

Situational disorganization happens to everyone from time to time, and people with some aptitude for organizing will eventually regain their equilibrium naturally: They will find a way to roll with the temporary inconvenience, or, if it's going to last a while, they'll change their previously adequate systems to compensate for the needs of the new situation.

Sometimes multiple episodes of SD will leave a legacy of clutter in a person's home (think of how often people have unpacked boxes a year after moving). In these cases, the disorganization can be severe in quantity, but it is not necessarily chronic, as you'll see in the next section.

Situational disorganization is always easier to conquer than chronic disorganization, even if there is a large backlog of disorganized stuff to dig through, because you are more likely to already have some organizing skills to apply to the project and you're less likely to be immobilized by negative emotions.

Chronic Disorganization

Chronic disorganization (CD) is tougher to reverse than SD. Folks who are chronically disorganized have inadequate organizing skills, so even extraordinary motivation and time commitment are not enough to solve the problem. Even worse, though, are the feelings of guilt and shame that most CD folks carry with them as a result of their organizing failures.

Chronic disorganization, as defined by the National Study Group on Chronic Disorganization, is "having a past history of disorganization in which self-help efforts to change have failed, an undermining of current quality of life due to disorganization, and the expectation of future disorganization." This combination of lack of skills and negative feelings makes it really tough for someone to have the energy and optimism to try again.

CD is like living with no safety net. CD folks are always just about to fall behind at something, just about to get in trouble for something, just about to be late for something...and that's normal, everyday life. If something out of the ordinary goes wrong on top of that (something that would cause situational disorganization in a non-CD person), life quickly descends into panic and chaos.

Please don't think that if you are chronically disorganized, you're hopeless. That's not at all true—it's just that you'll have a harder time helping yourself. Working with an organizer, coach, or other professional to tackle your organizing projects one at a time will help you to make progress much more quickly. Sometimes a friend or relative can fill this role, but a close relationship can actually be an interference

because the person will already have ideas about what you "should" do. Be careful to choose a helper who is empathetic and nonjudgmental, who will offer solutions and encouragement with a positive attitude and without demanding compliance, and who can help you to identify the organizing skills you do have (yes, you have *some*) and then build on them.

ARE YOU CHRONICALLY DISORGANIZED?

If you answer yes to these questions, you fit the profile of chronic disorganization:

1. Have you been disorganized most or all of your life?

2. Have your self-help efforts ultimately failed?

3. Does your disorganization cause you negative consequences or emotions on an almost-daily basis?

Determining Your Disorganization Type

The questions in the following table can help you determine which type fits your pattern of disorganization.

Table 1.1: Situational Versus Chronic Disorganization

	Situational	Chronic
Temporary?	Yes, but can recur	No
Can range from mild to severe?	Yes	Yes
Responds to self-help efforts?	Often yes	Often no
Impacted by outside forces/other people?	Yes	Yes
Causes significant shame?	Usually not	Very often
Involves large quantities of clutter?	Sometimes	Very often
Requires specialized solutions or one-on-one coaching?	Sometimes	Very often
Can be improved?	Yes!	Yes!

Summary

I'll bet you never knew there were so many potential reasons for disorganization, or that there are even different types of it! This chapter was meant to enlighten you to the fact that disorganization is not simply a result of laziness or stupidity—it's

actually the physical manifestation of one or more other key factors in your life, whether those factors are historical, emotional, physical, or environmental. Also in this chapter, you learned that there are important differences between situational and chronic disorganization, and therefore different approaches to improving each.

Making changes in the areas that you can control—meaning those within yourself—is the most important step toward improving your organization. If a health condition is impeding your progress, you now know how important it is to find ways to compensate for it. Becoming more organized requires behavioral and sometimes attitudinal changes, which take time to take root, so be kind to yourself as you begin to recognize and implement the positive changes that will help you to reach your organized ideal state.

It's important to also acknowledge the external factors that can hinder your progress, so in the next chapter we'll consider the influence of the people in your life and household—the ones who can make or break your success at finally getting organized.

Getting Everyone's Cooperation

I f you believe you do more than your fair share of housework and you think you're the only one who cares about organization, this chapter might prove you right. More importantly, though, it will also give you tools to bring about positive changes—tools that are more effective and more pleasant (for them *and* you) than righteous indignation, angry outbursts, or playing the long-suffering martyr.

Sit down with a calming beverage and your favorite highlighter and absorb this chapter. Read it slowly. When you are sure you can discuss needed changes in a neutral and upbeat manner—no blaming, no guilt trips, no button-pushing—schedule a family meeting and use the tools and knowledge in this chapter to present the importance of organizing in a positive new light.

To do list

- ☐ Assess your family's willingness to cooperate in your household organization
- ☐ Determine the best way to enlist your family's cooperation
- ☐ Find mutually agreeable compromises on organizational preferences

Investigate Your Home-mates

Now and then I encounter a client who knows how to be organized, but whose family gives zero cooperation. Usually the client has accepted the blame for the state of chaos in the home, thinking that if she (yes, it's usually the wife/mother) could just be more efficient, everything would get done and the house would always look great.

If this is your situation, it's actually better that you're reading my advice here in the pages of this book instead of chatting with me in person. Why? Because here, I can tell it like it is. If I were standing in your kitchen talking to you, with the rest of the family tapping their feet and waiting for me to leave so they can have you back, I wouldn't be able to speak freely about them. Here, I can lay it on the line for you without having to be diplomatic for the eavesdroppers.

Are They Doing It on Purpose?

If your home-mates are a factor in your lack of organization, the first thing to determine is just how actively they're thwarting you. Look at the continuum in Figure 2.1: On the far left is the ideal: The A's, a family of people who all have some organizing skills and who are all committed to working together. The next best thing is a family like the B's, whose members are cooperative, but they don't yet know how to do what needs to be done. Next is the less palatable combination of skills without cooperation, exemplified here by the C family—they know how to do it, but refuse to. And finally, the nightmare scenario: the D's, family members who don't know how to be organized and are utterly unwilling to make the effort.

Chances are your family members aren't completely hopeless. It's likely that each of you has different levels of commitment to organization, tolerance for clutter, and ability to see how things can fit in a space; most families are not all in sync on these points. It's also very common for one spouse to take on more of the household duties and for children to expect to have such things done for them—a situation every put-upon household manager resents sooner or later.

Organizing your home—bringing the current organization up to an acceptable level and, more importantly, maintaining it—will be much more difficult if your home-mates are not on board with the project. Read on for ways to accommodate differences related to organization, chip away at entitlement attitudes, and squeeze more cooperation out of your family.

How'd I Get Stuck with This Job?

Household managers often rope themselves into the position of sole and full-time cleaner-upper. It seems the more they try to teach everyone how to follow the systems, the less cooperation they get. Why does this happen? Here are just a few possible causes:

FIGURE 2.1

Levels of organizing skills and cooperation run the full spectrum among various families. The A's have it all: skills and team spirit; the B's are willing to work together but don't really know how; the C's have the ability but not the enthusiasm; and the D's have neither skills nor desire to improve.

- Your preferences are different from theirs
- Your definition of "neat" is stricter than theirs
- Your irritation threshold is lower than theirs
- Your ability to actually see dirt and clutter is keener than theirs

- You see the state of the house as a direct measurement of your effectiveness and of their love for you
- Your systems are too complicated for them
- You keep changing your systems, and they can't remember what you want
- You don't have actual systems—you decide where to put things as you go

In order to get household members to share the burden, you first must remove the obstacles that are stopping them. For the moment, set aside your righteous indignation ("They're just lazy, that's all! They just don't care!") and go for cool, calculated strategizing instead ("Fine, they don't want to. How can I get them to do it anyway?"). Understanding the reasons for others' disorganization will enable you to respond with patience and empathy rather than anger and judgment.

The following is one lesson that will take you far in making things more comfortable for everyone.

Try to See It My Way: The Art of Compromise

In organizing, we quickly learn that there are those who prefer to have things put away (closed storage) and those who prefer to have things out in sight (open storage). People often don't realize that they have this preference, but they all do. If you want someone to cooperate with you in keeping your shared space neat, you must at least identify and acknowledge their preference for open or closed storage. If you don't, they won't want to comply with your preferences and they probably won't know why. By acknowledging how they would rather have things, even if they don't get their way, you help them to give conscious thought to their resistance. Then when they consider leaving the toothpaste uncapped on the sink, their self-talk might go from "I'm leaving it here, it doesn't hurt anything here" to "Put it away; it bugs Mom to see it out."

Determining whose preferences "win" is an objective process that has nothing to do with who does the most work or how much you slave and slave and slave and get no thanks. This is not an emotional question—it's a question of differences in visual processing.

People who prefer open storage are reminded of an item's existence by seeing it. They have a hard time remembering it exists when it's put away. This is where we get that saying, "Out of sight, out of mind."

People who prefer closed storage are bothered by the visual "noise" of many different objects within sight. They don't need a visual cue to remember something exists—in fact, they're distracted by it.

To determine whose preference is more important, you must learn whose functioning is more impaired when they're forced to go against their preference. If you just

can't think straight with a bunch of stuff on every horizontal surface of your home, you need closed storage. If you can't find anything once it's put away, you need open storage. If there is one of each of you in the family, you need to compromise!

As the household manager, first determine what your preference is—in sight, or put away. Then determine everyone else's. Don't be surprised to find yours is different from theirs; you might also notice a correlation between the intensity of their preference and the intensity of their lack of adherence to your systems!

Now look for ways to compromise. Suppose you prefer closed storage and they don't. Here are some options:

- Allow a few often-used items to live out in plain sight, particularly if it's something you really want them to remember to use. For example, let them leave the bottle of vitamins on the kitchen counter, and tolerate a toothbrush holder on the sink (even if you still put your own toothbrush in the medicine cabinet). This is a good time to pick your battles.

- Be more tolerant of open storage for kids. As they get older, you can continue to persuade them to love closed storage, but when they're small, remember that you'll risk less breakage and fewer fits if you let them leave their stuff within easy reach. Use containers that require little dexterity to use—large enough to fumble an item into it, with no lid so it doesn't require using both hands, and on the floor so the container can't be dropped.

- Choose storage options that are contained but see-through. One example is glass-front kitchen cabinets. People who prefer closed storage can get used to stopping their glance at the glass and not looking through it, while people who prefer open storage can learn to ignore the glass and see what's behind it. The same is true of clear plastic storage boxes—closed-storage people see the neat, modular stack of containers, and open-storage people see the dozens of items in those containers.

- For things you simply must have put away, be willing to direct your housemates every single time they ask, "Where's the —?" Commit to answering with patience and without sarcasm, no matter how many times they've asked about that same item. If it's been several months and they're asking once a week, you can answer with, "The same place it was last time, dear," and eventually they will remember.

If you're the one who prefers open storage, use the points above to make your case while adding improvements that give your closed-storage housemates some visual peace.

There! Now it's not a power struggle, just a matter of visual processing needs.

MAKE IT FUN BY MAKING IT FUNNY

If you're fed up with the "where"s, as in "Where's my home-work?" and "Where's my wallet?" you probably tend to re-spond with a snappish, "I don't know; where did you leave it?" and perhaps even "It's not my job to keep track of your stuff!"

Stop. This dynamic is no fun for any of you.

When they ask "Where's my —" and you haven't moved it, pause as if deep in thought and then reply, "Okay, I give up—where?" Then giggle. Do this often enough and they'll get the point that you're not the household Lost and Found.

As my grandma used to say, you catch more flies with honey than with vinegar, so opt for humor over sarcasm, impatience, and anger. Humor can defuse a situation that could otherwise escalate into a fight, and that makes it easier to keep everyone cooperating.

To do list

- ❑ Adjust your attitude to allow for compromise
- ❑ Adjust your systems to make them workable for everyone
- ❑ Assess each person's available time and assign tasks equitably with a Family Time Commitments chart
- ❑ Use your Family Time Commitments chart to defuse resentment at chore time

Make It a Team Effort

Take another look at the list of possible reasons that you got stuck being the family Cinderella. We've talked about negotiating and compromising on preferences, which can help resolve many of the issues you might encounter when enlisting your family's cooperation in getting your home organized. Most of the issues that remain can be resolved with two more basic adjustments.

Things You'll Need

- ❑ Blank Family Time Commitments chart
- ❑ Pen or pencil

Adjust Your Attitude

I hope the information you've read earlier in this chapter has opened the door for you to continue looking for objective, cooperative solutions that take the problem of household disorganization to less personal ground. To that end, let's talk about two other causes for clashes in organizational approaches: your ability to see dirt and clutter, and your tendency to take it personally when they don't do it your way.

Consider those socks on the living room floor. You see them plain as day; your son claims he didn't see them at all. You find that impossible to believe. Well, believe it! Think of how 10 witnesses to a crime will each describe it differently. Why? Because no one can see and accurately comprehend every detail of a scene.

Your son is not leaving those socks there to make you mad. Why would he want you to be mad at him? Give him the benefit of the doubt and, instead of taking his inattention as evidence of something substandard in you, look at it as one more example of your superior ability to spot details—a skill you will continue to nurture in him.

Tell him the socks are there. Use a neutral tone: "Hey, Tim? There's a pair of your socks on the living room floor." Do not say, "Tim, darn it, pick up those socks; I am sick of looking at them!" Just point them out, the same way you would say, "Tim, a letter came for you today—it's on the counter." Give him a chance to see those socks as if they just now grew up out of the floor and say to himself, "Whoa, I *so* did *not* see those!" This is an opportunity for him to practice seeing details—don't obscure it with an angry outburst.

> **note** Remember, it's not about you. If a friend stops by and you both see the socks, just say, "Huh—guess Tim didn't see his socks lying there." Your worth as a person has nothing to do with where your kids' socks land.

Adjust Your Systems

Now that you know this is just a problem to be solved and has nothing to do with their love for you, and you know that there are legitimate reasons for everyone's differences, you can refine your systems for optimum cooperation potential.

With a fresh appreciation of your family members and their preferences and techniques for organization, take a fresh look at your systems. Are they too complicated? For example, does putting away the Kool-Aid pitcher require getting out a step stool to reach the top shelf of a high cabinet? Does coming home from school require stopping inside the doorway; removing hat, gloves, coat, and boots and putting them away; and hanging up the backpack, all before making a dash for the bathroom?

Have you been consistent, or have you changed the system each time you used it? For example, do things get put away in the same place each time, or do you keep relocating their homes? In your quest for the perfect organizing system, have you

introduced one "rule" after another, to the point that no one else can keep up without a Family Procedures Manual?

Is there anyone in your home who is affected by the challenges explained in Chapter 1? If so, what accommodations are you making for them? Are you expecting them to do things they're not capable of, or requiring that they do things your way instead of in a way that works better for them?

Take a good look at what's really happening. Set aside their occasional (or perpetual) attitudes, arguments, and rolled eyes, which can so easily make you that much more determined to enforce your will, and think about it objectively: Are you perhaps asking too much?

If you have high standards for your home and you feel compelled to have everything neat and clean at all times, expecting your family to maintain those standards might be too much to ask.

If it seems like you're always upset at the rest of the family for not being as organized as you want them to be, remember the concept of "organized enough": It's fair to ask them to cooperate on organizing issues that truly impact the functionality of your home and your life together, but beyond that, you might be asking too much.

note If I had a dollar for every time I've heard a group of women perpetuating the myth that men can't organize, I'd buy a huge billboard that says, "Yes they can! Stop telling them they can't! You're shooting yourself in the foot!" Organizing ability is affected by societal norms and expectations, not by gender. If someone tells you over and over that you can't do something, you're likely to believe it.

Create a "Family Time Commitments" Chart to Assign Tasks and Projects

By this point, you're in exactly the right frame of mind to determine an equitable division of labor for your household organizing tasks. You understand the various challenges that could be affecting each of you, and you've been honest with yourself about your expectations. Thus freshly enlightened, you're ready to assign some jobs.

Most people think of organizing and cleaning as chores that go hand in hand, and indeed it is difficult to do one without the other, so in this section you'll see references to both cleaning and organizing tasks.

tip As you work through the projects you want to complete with the help of this book, keep in mind that you'll be spending much more time on organizing here in the short term than you will in the future. Catching up on the organizing that has been neglected over the years will take more time than future maintenance of your new systems. So, take heart! You won't have to make a career of this.

Think of your catch-up organizing as a separate project, distinct from your ongoing household maintenance. Then, as with any large project, set aside blocks of time to

work on it. You can schedule these blocks into your week right next to the regular chores.

Check out the Family Time Commitments table in Figure 2.2. This table is a great example of one household's list of tasks and projects, complete with time estimates.

FIGURE 2.2

This time management tool begins with the number of hours in a week, then fills them in with each person's commitments and chores.

	Mom	Dad	Jenny (16)	Tyler (12)
Total Hours in a Week (24 x 7):	**168**	**168**	**168**	**168**
Time Commitments:				
Sleep (8/day)	-56	-56	-56	-56
Personal grooming (1.5/day)	-10.5	-10.5	-10.5	-10.5
Job (including commute time)	-50	-50	-10	0
School/Homework	-6	-2	-50	-45
Sports/Clubs	0	0	-4	-12
Chauffering kids	-8	-3	0	0
Other driving errands (grocery shopping, dry cleaning, etc.)	-2	-4	0	0
Hrs Left after Time Commitments:	**35.5**	**42.5**	**37.5**	**44.5**
Household Tasks (with hrs/wk)				
Laundry (folding/hanging) (3)	1	1	1	
Cooking family dinners (4x/wk) (4)		3	1	
Cleaning bathrooms (1x/wk) (1)			0.5	0.5
Cleaning kitchen (1x/wk) (1)			0.5	0.5
Taking out trash (1x/wk) (.25)				0.25
Cleaning litterbox (1x/wk) (.25)				0.25
Sweeping/mopping floors (1x/wk) (.5)				0.5
Vacuuming carpets (1x/wk) (.5)				0.5
Mowing lawn/clearing snow (1x/wk) (1.5)				1.5
Hrs Left after after Household Tasks:	**34.5**	**38.5**	**34.5**	**40.5**

Use Figure 2.2 as an example, then draw up a blank chart and fill in your own data.

A chart like this can be a great asset when you approach your housemates to enlist their help. Instead of pleading your case by begging them to do more so you can do less, simply show them the math.

Some pointers before you roll out your Time Commitments chart for family inspection:

- Complete the top portion, Time Commitments, to the best of your knowledge, or ask each family member to enter his or her own numbers. Beware that they will bristle if you fail to credit them for any hours they're already "spending" each week.

- When you assign time estimates to the items in Household Tasks, don't exaggerate, but don't underestimate either. Instead of a single number (15 min.), you might use a range (10–20 min.) to allow for differences in each person. Remember that others are likely to need more time to do as good a job as you would.

tip If you are employed in a job in which you are responsible for keeping up with recurring tasks and also for completing long-term projects (just like at home), and you're feeling overworked (just like at home), use the example in Figure 2.2 to create a chart of your time commitments at work. Use this approach to identify and quantify the work you do, then use your chart to show your boss, objectively and neutrally, that your workload is unrealistic.

Learn to Delegate and Negotiate

As the household manager, it's likely that you have been doing the majority of the cleaning and decluttering. But before you blame your family for treating you like a live-in maid, accept some of the blame yourself. Managers are often overworked because they don't know how to, or choose not to, delegate tasks to others. It could be perfectionism: You want it done "your way." It could be a misguided attempt at efficiency: It's faster to just do it yourself than take the time to teach someone else. It could be lack of planning: You do tasks as you think of them rather than following a list or a schedule, and this spur-of-the-moment approach is not at all compatible with asking others to take on some of the duties. Whatever the reason, you've painted yourself into this corner, and you can work your way out.

If your Family Time Commitments chart shows that you're doing more than everyone else, this is your chance to establish equity. The key is to present your case without sarcasm, condemnation, or anger. Pretend you're me, a professional organizer paid to advise this family on how best to divvy up the household chores. These people sitting around the table with you are not your relatives; they're your clients. They've never slighted you or taken you for granted, and you have no personal stake in the conversation you're having with them. Get a good grip on that perspective, and hold it!

While maintaining this cooperative atmosphere, gather everyone's input regarding the details of the Family Time Commitments chart. Is every commitment for each person listed? Are the times accurate? Have all of the regularly recurring household chores been listed? Allow plenty of negotiation and swapping—let the kids choose whichever chores they want, as long as they're taking their fair share of work hours.

Once this is completed, from now on you will each have a new perspective, and if everyone honors his or her commitments, the family will feel more like a team than a handful of individuals. If you find yourself tapping your foot in line at the grocery store and resenting that your husband is at home on the couch, you'll be able to

remind yourself that he spends just as much time on work, parenting, and household chores as you do—it's just that this afternoon is not his work time. If one of the kids starts whining about having to mow the lawn while his sibling plays video games, you can remind him that you're each doing your fair share of work, just not necessarily at the same time.

Quantifying the Value of Time

Using the Time Commitments chart not only equalizes the household workload but also teaches an important lesson about the value of time. Most people can easily calculate the monetary value of an object, but they would have a harder time quantifying the value of their time.

In Michigan, we pay a 10-cent deposit on each soft drink and beer container. If I drink a 12-pack of pop each week, I could return the bottles for $1.20. But the time it takes to rinse, store, bag, and transport those containers to the store is much more valuable to me than $1.20, so I recycle my deposit containers instead.

Apply this perspective whenever a task calls for an outlay of time in return for money, and ask yourself if the money you gain is really worth the time you spend. This line of thinking will probably spur you to reconsider driving out of your way to find the cheapest gas station or battling the crowds to save a few extra percentage points in the day-after-Thanksgiving sales.

Once everyone in your household is accustomed to valuing time in this manner, you can introduce other methods of keeping things fair. Suppose you discover Johnny forgot to clean the litter box. Should you sigh heavily and clean it yourself? I say no: A clean litter box is important, but not an emergency, so let it wait till Johnny gets home—then dock his allowance for Tidy Cat tardiness. If someone fails to perform a task to which he or she has committed and you end up having to do it yourself (for example, tasks that really are time-sensitive, such as getting the trash to the curb), charge for your time. You can opt to deduct the time you spent on the neglected task from something else that person wanted you to do, or you can take it out of his or her allowance. Either way, you demonstrate that time has value: You should be compensated for giving time, and the other person should be willing to pay for the time savings he or she gained.

Don't Abuse Your Power

As the leader of this household organizing endeavor, it stands to reason that you are the one with the greatest enthusiasm for decluttering each room. Therefore, you'll probably spend a fair amount of time working alone, weeding out both your and your family's belongings. Instead of seizing this opportunity to relieve them of stuff you think they don't need (even if they love it), show them that you respect their

rights by extolling the benefits of organization. Here's a crib sheet of reasons to love decluttering:

- Keeping floors and surfaces clear makes cleaning a snap.
- Owning fewer clothes and linens equals less laundry. It might seem that having 30 pairs of jeans would mean you could do laundry less often, but eventually, no matter what, you'll have 30 pairs of jeans to wash!
- Learning that you have permission to dispose of, donate, or otherwise discard things you're not using—whether they are inherently useful or not—brings a feeling of freedom that the majority of Western society never gets to experience.
- Realizing that you can toss things that make you feel sad, angry, guilty, ashamed, inadequate, or just bad in general—no matter who gave it to you and what they might say when they notice it gone—is a priceless lesson in empowerment.
- Weeding out the things you despise and the things you are lukewarm about leaves you with just the stuff you love, and surrounding yourself with adored items is a great way to live.

caution If you discard other people's belongings behind their backs and they find out, they will no longer trust you.

A METHOD FOR GARNERING COOPERATION: LOVE AND LOGIC

If you're tired of yelling, threatening, and punishing your kids in an attempt to get them to put their stuff away, here's an alternative: the Love and Logic system.

Love and Logic teaches parents to use empathy and humor while establishing boundaries and helping kids to learn from their mistakes. It emphasizes mutual respect, and it helps kids to learn the cause-and-effect relationship between their behavior and the consequences (good or bad) of that behavior. By eliminating power struggles, Love and Logic lets parents step out of the role of "Bad Guy" and focus on enjoying parenthood.

Visit www.loveandlogic.com for more information and to check out the many books, products, and seminars available to help you learn Love and Logic.

Summary

In this chapter, you learned many ways to get everyone onboard with your organizing efforts. Now you can identify and compensate for each person's strengths and challenges, and the entire family can share equally in the division of household tasks. You are ideally positioned for some organizational solutions, so let's move on to Chapter 3, "Principles to Live (and Organize) By"!

3

Principles to Live (and Organize) By

Here's something you might find comforting, or unnerving, or both: There are no hard and fast rules for organizing. There are some widely accepted and respected guidelines, and there are principles such as the ones I'm about to offer you, but even the most universal of organizing concepts is not one-size-fits-all. The key word here is flexibility: Everything must be customizable person by person, and if a "rule" is not adaptable to your unique needs, it's not valid.

This chapter describes eight principles that I think you'll find relevant to organizing the spaces in your home. There are seven that tell you where to start and one that tells you when to stop. (Intrigued?) Many of them apply to other types of organizing, too, such as data and time management. If they inspire you to move beyond organizing your belongings at home and into also organizing your time, your paper, or your space at work, so much the better!

Understanding these principles from the outset will give you a significant head start toward the hands-on organizing coming up in later chapters: They allow you to take a much more targeted

approach, because you're better able to antici-
pate the results of your efforts, and you have a
global perspective to keep yourself working
according to your priorities. Carry these princi-
ples with you after you've reached your orga-
nizational ideal: They'll help you make
prudent choices when your systems need
future updates.

note Because this chapter explains some basic prin-ciples of organizing, you won't see the typi-cal "To Do" and "You'll Need" lists. You'll find plenty of those in later chapters, however, when we put these principles into action!

To do list

- ☐ Learn the eight principles of organizing
- ☐ Make a habit of applying the principles to your home organization efforts

Have a Home

Everything you own should have a home within your home—a place it belongs, fits, and can go to when not in use. It doesn't necessarily have to be in its home very often (think remote controls that are put away only when company's coming) but when it is time to tidy up, those reserved parking spaces must be accessible.

Adhering to this principle accomplishes two things: It makes it easy for you and anyone else in the household to put things away where they belong, and it forces you to decide, for every last thing you own, where it should be stored.

Choose a small area that is always cluttered in your home and look at each of the objects on that surface. Ask yourself where each of them belongs. If you don't know or have never decided, well, there's the problem: How can you put something away when it doesn't actually *belong* anywhere?

Figuring Out Where Things Should Live

Assigning homes to every last object can be tough. Some things are easy, and they're the ones most likely to be put away on a regular basis. Other things are difficult for a number of reasons:

1. It won't fit where you store the other things like it. For example, many people have far more bath towels than they have linen closet space; it doesn't seem out of control unless you manage to get all of the laundry done at one time, and then you can't fit it all into the closet!

2. It is used frequently and getting it back out each time would be too inconvenient. This is why keys, phone chargers, remote controls, carryout menus, coffee-making supplies, calculators, and pens tend to live on the countertop instead of in a drawer, and it's why there's always a logjam of shoes by the main entryway.

3. It's a lone wolf that has nothing in common with anything else you own, so you haven't figured out where it logically belongs. Consider that back-scratcher you got from Disneyland. It's useful as all get-out and you want it handy when it's needed, but where do you store something like that?

4. It's something you will have only temporarily, and you need to remember to do something with it while it's there. A great example is a course of antibiotics: You leave the pills out on the counter to remind yourself to take them. Another example is the daily mail. In theory, you intend to process it each day. In practice, it piles up because it's a to-do, not a to-put-away.

5. When it's needed, it's needed quickly, so it tends to be never completely put away. Things like this might have kinda-sorta homes, like the fly swatter hanging from a stray nail by the back door. (Yuck.)

6. It belongs to someone else. Other people's DVDs and leftover containers often play a part in cluttering up our homes. The idea is to leave it out where you'll notice it the next time that person comes over or you go to see them, but it doesn't work that way: Their stuff becomes part of the landscape just as quickly as our own stuff does, and their visit won't be enough to prompt you: You're both likely to walk right by it as they head for the door.

Choosing homes for everything you own is hard enough. Then, getting stuff put away presents its own set of challenges. We'll look at these in Chapter 6, "Making Homes for Your Keepers."

note Everything you own should have a home within your home—a place it belongs, fits, and can go to when not in use.

Like with Like

You have enough things to remember—where your stuff is doesn't have to be among them. Give your brain a break by grouping "like with like."

When you store similar things together, you reduce the burden on your memory. Instead of memorizing where each item has been dropped randomly throughout your house, you can group things in categories and then you only have to remember where the entire grouping is supposed to be.

Here's an example from my house: Say you need a flat-head screwdriver. There are only a few places it could be: With the other screwdrivers in the garage, on the workbench in the basement, or in the mini-toolkit in the kitchen. It is 99% guaranteed to

be in one of those places. (Not 100%—organizers are human too.) So, your search is automatically much less daunting—just three possibilities instead of an infinite number of options all around the house and yard.

Some people get the concept here but are immediately overwhelmed at the idea of choosing just one category for an object. They see multiple ways to categorize any given item, so they figure that in order to choose one item's category, they'll have to categorize everything else all at once. They see the need for a Grand Plan, complete with graph paper or a computer database.

Stop. It's not that complicated. Just pick a category, put the stuff together, and if you don't like it, change it later! Accept that you have a creative mind and you will always see more than one "right" way to organize. Then, in the interest of time, just pick one and do it!

tip

Learn to think in categories and store similar things together.

Contain It

We've all heard this buzzword: boundaries. Just like your significant others, your children, your pets, and yourself, your stuff needs boundaries too. If you let it just do its thing, pretty soon it will be walking all over you, metaphorically speaking, and you'll be literally walking all over *it*.

How do you set boundaries for belongings? With containers! Whether you prefer things put away or in sight, some degree of container usage is necessary.

A container is anything that keeps your stuff together. It can be a drawer, a cabinet, a box, a basket—anything with edges (actual walls or implied stopping points like the edge of a shelf) that you do not allow your stuff to cross.

Sometimes the only "container" in your life is your home: If your stuff isn't falling out the front and back doors, it's contained (well, technically). But you want to do better than that, right? Start thinking of your home as a collection of nesting containers, like in Figure 3.1. The main one is the house or apartment. Within that are rooms, and within those are fixed storage such as closets. Within those closets are free-standing containers such as shoe boxes. Within those boxes, you might have even smaller containers such as medicine bottles or grooming products.

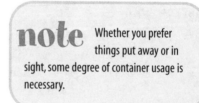

note

Whether you prefer things put away or in sight, some degree of container usage is necessary.

FIGURE 3.1

Your home is one big set of nesting containers: Pills are contained by a pill bottle, which is housed in a medicine cabinet, which is built in to a bathroom, which is a subset of the entire home.

Your Home = Container

Bedroom

Suitcase	T-shirt drawer	Books
Shoeboxes	Sock drawer	Reading glasses
Trunk	Jewelry box	TV remote
Closet	**Dresser**	**Nightstand**

Bathroom

Makeup	Towels	Toilet paper
Medicine	Sheets	Trash bags
Bandages	Soap Bars	Cleaning supplies
Medicine cabinet	**Linen closet**	**Sink cabinet**

Kitchen

Cereal	Dishes	Silverware
Cans	Coffee cups	Toolkit
Chip bags	Spices	Dish towels
Pantry	**Cupboard**	**Drawer**

Living Room

DVDs	Coats	Books
Remotes	Umbrellas	Knick knacks
Toys	Vacuum cleaner	Photo albums
Entertainment center	**Closet**	**Shelving unit**

CHOOSING YOUR CONTAINERS

Don't run out to buy an array of containers just yet. It's better to gather the stuff to be contained, then get a container that is exactly right for that grouping of stuff. For example, say you want to store your music memorabilia so you can display it when you get the basement refinished. You could just buy a big plastic tub and then round up the items, but suppose you've forgotten something odd-shaped, such as rolled posters? Now you have a container that's not long enough for the posters, so you need to either go back to the store for a better container, or crush your posters. Best advice: Assess the category of stuff, then make an educated choice for the container.

You'll learn more about your options for "containerizing" in Chapter 6.

Go Up

If you're indoors right now, look at the floor around you. You probably see some furniture, including the piece you're sitting on, and some other heavy things such as appliances, cabinets, or big potted plants. There are probably also some portable things such as a magazine rack, a file box, a trash can, a dog bed, or a footstool. And then there's the stuff that's not really supposed to be there: piles of newspapers, clothing, toys.

Now look up at the ceiling. What's there? Maybe a light fixture, a ceiling fan, some hanging plants. There might be a row of shelves high up on the walls. Perhaps there's a skylight. No matter what's up there, there's bound to be less than what's on the floor. If you could turn the room upside down and have that empty ceiling as your floor, wow, imagine everything you could do with that space!

We tend to allow ourselves to be controlled by gravity, crowding the floor with clutter and ignoring the elevated options that are there for the taking. I say, ignore the floor! Set your sights higher. Use shelves, wall-mounted racks, pulleys, nets, and anything else that will free up floor space and make good use of the empty air up there.

note Once in a while I encounter clients who I eventually identify as Yeah Butters. I say, "You have more clothes than you can fit in this closet," and they say, "Yeah, but I don't want to get rid of any of them." I say, "You told me you don't need these books any more," and they say, "Yeah, but they're too good to toss." I say, "Your decluttering wouldn't be so daunting if you would do a little each day," and they say, "Yeah, but I don't have time." If you're thinking "Yeah, but…" as you read this book, you're not ready to get organized. You will need to figure out what's blocking you before you'll see real progress.

From now on, whenever you're looking for a place to put something, think up instead of out. Can it stack? Your stacking options improve with the right choice of container. This principle applies to not just the floor but to enclosed spaces as well. Look inside a closet with a shelf. Is there no room on the floor but empty air above the shelved items? A-ha: An opportunity to go up!

tip Use wall and overhead space to increase your storage options.

Be Systematic

"Organized" is by definition systematic. It's not possible to be organized without some sort of system, and usually it's a game plan made up of multiple systems that work together to give you your overall level of efficiency.

If you feel the need for more organization in your life, what you're actually yearning for is one or more systems. Sure, you might chafe at the idea of having to actually follow that system, but it really is what you want and need. You might not like the

idea of following a system, but you'll appreciate the end result.

The trick to not feeling as if you've given up control is to write your own rules. Don't do what some professional organizer says just because she's supposed to be an expert. Don't just passively adopt someone else's system word

> **note** Have systems, methods, checklists, habits, routines—whatever tools you need—and be consistent in their use.

for word. Instead, make it your own. Adapt it to your needs, preferences, tolerances, and priorities. Requirements that are imposed upon us can be intolerable; parameters that we establish for ourselves are a disciplined way to expedite the accomplishment of our goals. THAT is why they're good for us.

Be Decisive

The hardest part about organizing is not the physical work, and it's not even parting with once-beloved objects. It's the actual decision-making. Everything is a choice, which is why organizing can be so exhausting: It's just one decision after another.

If I had to name the single most significant characteristic that separates organized people from disorganized people, I would say decisiveness. Those who are able to make decisions quickly and accurately have a much easier time in life than those who can't. This doesn't mean that indecisive people are inferior. It just means that they tend to get in their own way. Luckily, this is a tendency that can be adjusted once it's identified. Here are some techniques you can use to assess your decisiveness:

- Watch yourself for a few days whenever there is a decision to be made. Compare your speed to that of others. Look at mundane things such as how quickly you make up your mind at the drive-thru, how many times you equivocate about whether to buy that magazine from the checkout line, or how long it takes you to choose a movie from the video rental store.

- How much of your routine is the same each day? How much thought do you give to your breakfast or lunch? Do you drink your coffee the same way every time? Do you take the same route to work? Do you leave at the same time (or intend to)? People who follow pretty much the same routine every morning and evening often do so because they know what works and they don't want to bother rethinking it every day.

- When something new comes along, how much time does it take you to process it? If someone calls to invite you out on Saturday, do you need time to think about it, or do you open your planner and give them an answer right then?

- What kinds of decisions do you agonize over? Do you debate whether to call or email? Do you usually wear the first outfit you put on each day, or do you

try a few things? How are you with gift-buying? Can you choose something for the person and be done with it, or do you need to shop, compare, think, and shop some more?

- What would it be like for you to buy a car or house? Assuming there are a number of attractive choices available, would it take days for you to choose one, or months?

- What do friends and family say about your decisiveness? Do people in line behind you get impatient? Does anyone say, "Just make up your mind already" or "Just pick something, please"? Do you exasperate them by "changing your mind" again and again (which actually means you never really decided in the first place)?

If you're not accustomed to making decisions immediately, successfully (meaning the result is what you intended), and with finality, getting organized will be a shock to your system. But, it's my fervent belief that identifying the problem is half the battle, so if you now see indecisiveness in yourself, congratulations! You're halfway to a solution.

caution Don't defer decisions: It's a form of procrastination and a big reason for clutter pile-up.

Make Conscious Trade-offs

When you're in the process of getting organized, and later, when you've achieved the level of organization you want and you're maintaining, you will find that you are constantly called upon to make trade-offs. Here are some examples:

- More space or more stuff. Which do you want more: to own everything you want to own, or to have enough room in your home? You probably can't have both. (If you could, you wouldn't need this book, right?)

- More space or more time. Which do you want more: fewer clothes (thanks to judicious pruning of your wardrobe) with frequent laundry duties, or tons of clothes in jam-packed closets and drawers with occasional laundry marathons?

- More stuff or more money. When considering a new purchase, which do you want more: the item or the money? When considering purging an existing item, which do you want more: the object and its attendant upkeep costs (cleaning, protecting, the square footage it occupies) or the availability of that space for something else?

The decisions you make with these trade-offs determine how organized you are and will remain into the future. Get used to making these trade-offs consciously, based on how they contribute to your organizing priorities. Here are some examples from my house:

- I have two towel racks in the main bathroom that will hold a total of eight rolled bath towels. I wanted to use wall space instead of cabinet space to store towels (applying another key concept: Go Up), so I have consciously chosen to own just eight bath towels and to do laundry more often.

- My mom gave me a new set of dishes (service for 12) for my last birthday. I decided to donate the old set, because I have no need for more than one set of dishes. I considered keeping the old set as a backup, an option that most people find tempting (even professional organizers), but I satisfied that urge in a different way. I put only eight place settings from the new set in the cabinet for regular use, and stored the other four as replacement parts for the breakage that's bound to occur eventually.

- Last year my Great-Aunt Lil passed away and bequeathed all of her furniture to me. It's beautiful and well-made, and although I already had a houseful of furniture, I wanted to incorporate these pieces, so I made some trade-offs and sacrificed some space. Now my living room is stuffed with a couch, a loveseat with two built-in recliners, two armchairs, a center coffee table, an entertainment center, two bookcases, and three end tables, and so it's less spacious than I prefer, but I value these items over the space they would free up.

- I go shopping for groceries and household supplies more often than I would like to. I choose to make more frequent trips as the lesser of two evils: I don't like shopping, but I *really* don't like schlepping dozens of bags from store to car to house, making room to stockpile months' worth of food and supplies, or spending hundreds of dollars at a time. Plus, I try to eat fresh produce every day, so I have to go to the store at least once a week anyway.

What trade-offs are you making right now that could be changed to better serve your organizing efforts?

> **tip** Get used to making trade-offs consciously, based on how they contribute to your organizing priorities.

Get Organized Enough

If the previous guidelines got you all wound up and anxious about organizing, here's one to bring you back down to earth: Endeavor to be only as organized as you need to be, and no more.

How do you know when you're organized enough? When you are able to function optimally (not perfectly). If you answer yes to these questions, you are probably organized enough:

- Can you find what you're looking for in a reasonable amount of time?
- Can you move through your home without the danger of tripping over clutter or knocking a stack of it over?
- Can you use all of the areas of your home for the purposes for which they were intended?
- Do you know what you own well enough to not inadvertently purchase duplicates?
- Does your home look the way you want it to look, rather than appearing too messy?

When you are organized enough, your efficiency, mobility, budget, and pride are not hampered by organizational issues.

People often ask me whether my home has a "junk drawer." They roll their eyes in a combination of intimidation and dismissal when I answer no. Folks, I'm not doing it to be superior! For me, "organized enough" would not include a whole drawerful of miscellaneous stuff: I wouldn't be able to keep mental track of it. I need a lot of structure and categorization of my belongings. But some people are able to remember just about every item in a container of unrelated things, and so for them, having a junk drawer (maybe even more than one) qualifies as organized enough.

tip Organize just enough for efficiency, then stop!

It's not a question of what's right—it's a question of what's right for *you*.

FENG SHUI

For another perspective on the benefits of decluttering, do some reading on the principles of feng shui. Often described as the ancient Chinese art of placement, feng shui endeavors to balance your chi, or life energy. Decluttering is a key component of this process, because discarding belongings that are broken, no longer used, unneeded, or associated with bad memories has a dramatic positive impact on your chi. Appendix A includes resources for further information on feng shui.

Summary

With the eight key organizing principles you've learned in this chapter, the causes of disorganization highlighted in Chapter 1, and the techniques for garnering familial cooperation in Chapter 2, you are now well-equipped to dive into decluttering! Part 2 opens with Chapter 4 on planning your attack, followed by Chapter 5, which takes you through the purging process. Throw on some comfortable clothes and some peppy tunes, and clear that clutter!

Part II

Clearing the Clutter

Organizing Your Attack

Congratulations! You've completed Part 1, "Seeing the Patterns," which means you're already more organized. Now you have a much clearer picture of how things got the way they are and what you're going to do to correct it and prevent it in the future.

Before you can organize your home, you need to organize your plan of attack. Like any complicated project, this one has many intertwining contingencies, pitfalls, and shortcuts, and planning for these before you encounter them is the best way to ensure you'll achieve the results you want in the shortest possible time. In this chapter, you learn how to assess your current organizational situation and needs, then use that information to plan your first organizational project.

No formidable opponent can be defeated without a strategy, so let's get started with your plan to defeat disorganization!

To do list

- [] Get motivated to conquer clutter
- [] Identify the areas most in need of organizing
- [] Spot contingencies that impact where you will start and choose your starting point

Things You'll Need

- ❏ Organizing Matrix from Figure 4.1
- ❏ Flow chart from Figure 4.2
- ❏ Pen or pencil

Know Your Enemy: Clutter

You want to get organized. What's your biggest obstacle? Clutter. Clutter is the stuff that fills up your home. You can think of it as the physical manifestation of disorganization—the damning evidence, if you will.

Everyone has a slightly different opinion of whether a given object is clutter. One way to differentiate clutter from essentials is by purpose: Does the object do a job for you? If so, it's essential, and if not, it's clutter. Now, that job could be to help you brush your teeth (the toothbrushes in the stand on the counter), it could be to give you something beautiful to look at (the pictures on the wall), or it could be to make you feel good by bringing back a happy memory (that little jar of sand labeled Beachfront Property). So one way to minimize clutter is to get rid of the "unemployed" objects in your space.

Another way to identify clutter is visually. You've probably had the experience of looking at an area filled with items, even essential items, that nonetheless looks cluttery or "busy." It's an unpleasant sensation—as if those items are jockeying for your attention when they should be sitting still and staying out of your way. Everyone's tolerance level for this "visual noise" is different—some people can't stand having anything out in sight, while others can't function with everything "out of sight, out of mind." For this reason, weeding out the slackers is not enough: You still must store the remaining essentials in a way that won't drive you crazy!

So, yes, you do have your work cut out for you. Lest you find yourself thinking, "What's really so bad about my old familiar clutter?" here are some reasons to get rid of it:

- **Clutter drags you down**: Excess stuff surrounding you is a major energy drain. It makes you less productive and unable to concentrate or think clearly, and it leaves you unsure of exactly what you own ("I swear I had a…"). All of this uncertainty in your living space makes it impossible for you to function at your highest capacity. When your space is simple and not overstuffed, your mind has more room to work. You can concentrate and think quickly when you want to, or relax, unwind, and think of nothing at all when you want to, and never find yourself distracted, interrupted, or bothered by objects in your environment.

- **Clutter can be dangerous**: Clutter can actually kill you. Piles of clutter in walkways (especially stairs) present a tripping hazard; stacks of flammable materials constitute a fire hazard; teetering towers of boxes and items jammed onto overhead shelves increase the chance of something falling and hurting you; excess furniture or boxes in front of doors and windows make your home less accessible to emergency personnel; and lingering clutter that accumulates dust, grows mold, or attracts pests creates a health hazard.

- **Clutter can be embarrassing**: The FlyLady, a web-based anti-clutter crusader, calls it C.H.A.O.S.: Can't Have Anyone Over Syndrome. This embarrassment can make you hesitate to bring in repair people when needed, meaning that leaky pipe will keep leaking, damaging your home's structure and increasing your water bill. Worst of all, you'll be unlikely to invite friends into your home, and the resulting social isolation will compound your feelings of shame and helplessness.

So clutter is detrimental to your health, happiness, and potential for achievement. That pretty much proves the importance of de-cluttering, don't you think?

Pinpoint Your Trouble Spots

You probably have some idea of what your biggest clutter-causing problems are. But you can use the table in Figure 4.1 to know your enemy even more precisely. The Red Letter Day Organizing Matrix gives a visual representation of the three biggest organizing problems—stuff, paper, and time—and the three stages of life for each: when they're on their way in, while they're staying, or when they are (or should be) on their way out. To use this tool, fill in the blank form below the list of common problems, and see which of the nine areas is most problematic for you.

> **note** In this book, we're focusing solely on organizing your stuff, so if the Red Letter Day Organizing Matrix shows that you have big problems with paper and time as well, make those your next organizing project!

Here are some basic guidelines for interpreting the results of your matrix:

- **Stuff Coming In**: If you have a big pile-up in this square, it's because you're acquiring things faster than you can organize them and in quantities that are unmanageable for you. Compulsive shoppers tend to have the greatest trouble with stuff coming in. The good news about stuff coming in is that you can *stop* it! Once you've identified this as a specific problem, you can address it by working on changing your habits so they support instead of thwart your organizing efforts.

Common Organizing Problems

	Coming In	Staying	Going Out
Stuff	• Gifts received • Shopping acquisitions • Mail orders • Supplies related to starting a new project • Stuff associated with a new baby or pet	• Toys • Stockpiles of household products • Clothing and linens • Kitchen supplies • Home repair tools/supplies • Hobby supplies	• Trash/recycling • Donations to charity • Others' things to be returned • Old/broken/unused clothing, toys, furniture
Paper	• Daily mail • Newspapers • Memos left on desk • Inbox • Papers sent home from kids' schools	• Permanent storage for vital records • Archiving taxes • Maintaining research files • Household files for finances, manuals, receipts • Project files	• Shredding/recycling • Outdated publications • Expired coupons • Earlier drafts of revised documents • Printouts that duplicate electronic files
Time	• Overtime hours • Changes in school schedules • Volunteering • Clubs or sports activities • Requests from others • Occasional events	• Special schedules at holiday times • Commuting • Coordinating family members' schedules • Handling unexpected delays	• Saying "no" • Delegating work to others • Asking for help • Weeding out time-consumers • Streamlining tasks

My Organizing Problems

	Coming In	Staying	Going Out
Stuff			
Paper			
Time			

- **Stuff Staying**: These items are yours for the duration, and you have no intention of getting rid of them. This square is most troublesome for people who have difficulty letting go of their stuff. It's also a problem for those who don't know what they have, so they purchase duplicates. If this is your

biggest problem area, Chapters 5 and 6 will make a world of difference for you. You'll greatly reduce the bulk of Stuff Staying when you complete your purging in Chapter 5, and you'll optimize the organization of the items that "made the cut" in Chapter 6.

- **Stuff Going Out**: These are objects that are on their way out (such as returnable bottles), or should be leaving but are lingering for some reason. Items that can get stuck in this square include things you'd love to get rid of but don't know how to dispose of, things you intend to donate (but haven't), or things that you know are trash but you're so used to them that your eye keeps passing over them on trash day. Another notorious offender in this category is stuff that belongs to other people: The kids' left-behinds from when they moved out, for example. Once you've invested time in organizing the stuff you *do* want, the stuff in this category will become even more intolerable to you, and you'll find ways to get rid of it.

JUST HOW DISORGANIZED AM I?

If you're wondering how your clutter measures up against others', let the National Study Group on Chronic Disorganization tell you. The NSGCD's Clutter Hoarding Scale provides a ranking of household clutter from 1 (acceptable) to 5 (uninhabitable). The Clutter Hoarding Scale was developed as a tool to help professional organizers and experts in related fields compare "apples to apples" when assessing clients' homes, and it can give you some perspective, too. Look for the Clutter Hoarding Scale Fact Sheet in the General Public FAQs on the NSGCD website: www.nsgcd.org/pdfs/fs006.pdf.

Identify Your Urgencies, Contingencies, and "Pain Points"

One of the biggest reasons people throw up their hands and abandon their organizing efforts is that they can't decide where to start. It all seems urgent or at least important, it's all connected, and it's all *so* irritating... so how do you decide what to do first?

In most cases, it really doesn't matter where you start—the important thing is that you *do* start. However, there might be some options that will bring you quicker gratification, making you more likely to see the entire project through to completion, and there might be some areas that must be done before others for a variety of reasons. The following sections can help you identify the factors to be considered as you decide where to start.

What's "on Fire"?

Are there any deadlines that are relevant to your choice of where to start organizing? For example

- Orders from the city or landlord to clean up your yard or storage area
- Things that must be found by a certain date, such as library books or other borrowed items
- A room that must be clear in time for someone to move in
- Scheduled repairs or deliveries for which an area must be cleared, for example, installation of new carpet or the arrival of a new appliance
- An event to be held in your home for which you want certain areas tidied

If you are under the gun with one or more deadlines, you'll want to address the affected areas first or very early in your organizing. If nothing is deadline-specific, I'm happy for you! What a relief! Now you can choose based solely on contingencies and preferences.

What Areas Are Contingent on Something Else?

You're probably familiar with this concept from remodeling or decorating your home. For example, in my office, I needed a new floor, but couldn't replace it until I'd painted the walls and ceiling, because I wanted to be able to slop paint on the old floor and not fuss with drop cloths. But I couldn't paint the walls until I addressed the problem of the water damage on the ceiling, which I discovered was from active leaks in the roof. This meant the whole office remodeling project had to wait until I got a new roof.

So my original, relatively simple floor-replacement project became

1. Get a new roof
2. Repair the water damage on the office ceiling
3. Paint the ceiling and walls
4. Replace the floor

These steps had to be done over time, because it wasn't in my budget to do it all in one crazy week. So, in the midst of all of it, I still had to use the office to do things

such as writing this book! To complicate it further, each of those steps required some disruption to the use of the office: The equipment had to be unplugged and covered at the least, and sometimes everything had to be moved out of the room. It would have been great to be able to get it all done at once, without taking two steps forward and one step back, but hey, that's life.

That's what I mean by contingencies.

What contingencies are complicating your decision on where to start? Perhaps you

- Can't do the kitchen or kids' rooms until you do the basement, because a lot of kitchen and kids' stuff will go down there
- Can't do the shed until the weather is warmer
- Can't do the spare room until after you paint the bedrooms, because that's where all the bedroom stuff is being stored
- Can't do the garage until you have the money for shelves and cabinets
- Can't do the attic until the kids get their stored stuff out of it
- Are going to be moving, but you don't have a new house yet, so you don't know what you'll have room for

If you have areas that are contingent on other areas, work backward through them until you find the "source" space—the area that will start the ball rolling for everywhere else. This space is often the basement, attic, or another storage area, because as you move items out of your living spaces (after judiciously purging), you'll need organized storage areas to move them into.

tip

If you have areas that are contingent on events, such as a wedding or a move, start in an area of your home that is not affected by that event. If you're concerned that your organizing in a particular area will be too disruptive to the use of that area, plan the project for a time when it will be least hindering, and then tough it out.

Remember, these complications could make you feel like chucking the whole project because it's going to be just too much trouble, but don't. In the end, it will definitely be worth it: You'll make up in efficiency what you lost in inconvenience, and you'll enjoy the space so much more.

What's Driving You Nuts?

What are your organizing "pain points"? What makes you wince just thinking about it? (These are probably the reasons you bought this book.) Make a list of them—jot down everything related to disorganization that's really bugging you.

These are probably areas you've already thought of in the last two sections. If something is really bugging you, it's probably urgent if not on fire, or it's probably blocked by some contingency.

Choose Your Starting Point

Use the flow chart in Figure 4.2 to decide what to do first. You'll find that if you have something that's on fire *and* driving you nuts, that's definitely the place to start; if it is contingent on something else, do the other thing first, *whether or not it's on fire and/or bugging you!* If you have more than one of these, start with the one that would have the worst negative consequences if left undone.

> **caution**
> Here's a spot that's ripe for a "yeah-but":
> "Yeah, but I would be so happy if I just got this other thing out of the way first, and it won't take that long…." This is one of the most common ways people get off-track with organizing. They do the fun, quick, and easy jobs first and leave the difficult, distasteful, or scary tasks "for later," and end up exactly where they were to begin with. It's your decision, but don't say I didn't warn you!

FIGURE 4.2
Use this flow chart to determine what area to organize first.

Okay, that covers the first area you're going to organize, but what about the rest of the house? Use the same system to determine what you'll do second, and third, and so on. Use Figure 4.2 when you get stuck deciding what to do next, and keep at it until you're organized. That might seem like a tall order, but remember the principle of organized enough, remember to pace yourself, and eventually you *will* be done!

To do list

☐ Establish the purpose of the space to be organized and decide what does and does not belong in the space

☐ Assess the tools and supplies you'll need

☐ Plan your organizing time

Make a Plan

You have your area scoped out; now, what are you going to do in it? Refer to Figure 4.2 again—the chart you used to determine what area you'll organize first. You can use the same thought process to decide the order in which you'll do the tasks that area requires.

Is there anything more urgent than anything else in this space? For example, do you really need to clear out the items under the window because rain is leaking onto them?

Is there anything that's really driving you nuts in here? For example, are there dirty clothes that you just have to get into the laundry?

Finally, are there any contingencies? When considering what tasks to do first in a space, there very often are some that need to be done before others. The simplest example is that you have to deal with the top layer of stuff before you can get to the items buried at floor level.

Here are more questions to get you started in planning your organizing tasks:

- **What Is This Space For?** Look around the space and consider its function. What is it supposed to be doing, and is it available for that use, or is everything in the way? Keep the space's reason for being in mind as you organize it. Like anything else, when you

note What if the space has no real purpose, but you just want it to be neat? Well, if it has no purpose, why is there anything at all in it? If you've been using it as a "junk room" and you have no other intentions for it, go ahead and let it be a storage space: Not a "junk room," but a "household storage room" or a shared storage space with a section for each family member. It's okay to designate a space for miscellaneous storage—just make sure it's organized, and call it what it is.

have a specific goal in mind, you'll reach it much more directly. When you know what this space is for, you'll then know which items belong in it and which ones don't.

- **What Belongs Here?** Now that you've determined the purpose of the space, you can easily begin to weed out the items that don't belong in it. This is what we call purging (covered at length in Chapter 5, "Let the Purging Begin").

 When you've purged the items that don't belong, you'll be left with some—but not all—of the items that do belong in this space. In addition to organizing the purge survivors, you'll need to accommodate more items that will be coming into this space as you continue organizing it. We'll get into this in depth in Chapter 6, "Making Homes for Your Keepers."

- **What Tools Need to Be Added?** You can't just leave everything in neat piles on the floor: Chances are you'll need to employ shelves, cabinets, or other furniture, and a variety of containers to organize the items to be housed in this space. This will also be addressed in Chapter 6.

FOR NOW, SKIP THE PAPER

Depending on the space you've chosen, you might encounter a lot of paper in addition to the belongings that need organizing. Remember, in this book we're focusing on organizing objects, not paper, so for now, ignore any paper that isn't time-sensitive: Choose one place to put bills and anything else with a deadline, and box up any other documents or other data you find to be dealt with later. Keep in mind that "later" might be a year from now, so don't set aside anything with a deadline!

There are some types of paper that you can treat as objects, at least during the purging stage. These include books, newspapers, magazines, catalogs, and photos.

Why not just organize paper now? Two reasons: Organizing paper involves techniques that are different from those employed in organizing objects, and the pace at which you can organize paper is much slower than that of objects. This means that the two activities are better done separately. So, for now, you get to take a pass on paper!

Gather Necessary Supplies, Tools, and Assistance

When you're ready to begin your organizing project, there are three types of help you're likely to want or need: supplies, tools, and people.

> **tip** Remember: Every project is a collection of tasks. The first area you've chosen to organize is a project, not a single task—so don't expect to complete it in one giant step!

- **Supplies** are things that get used up as you complete the project. The supplies you're likely to need include bags for trash, boxes or bags for donations, shelves or cabinets, and containers for storing the items that make it through your purging process. You're also likely to need something to label your containers, such as a thick marker or some stick-on labels. Also, be sure to have plenty of water and some healthy snacks to keep your energy up!

> **tip** Gather all of the supplies you already have that you can put toward this project, and buy whatever you're going to need right away so you'll have it handy when you're in the middle of your organizing session. Before buying containers, though, read Chapter 6 to make sure you're getting exactly what you need.

- **Tools** that could prove useful in your organizing efforts include a trash can or trash bag frame, hand tools for hanging shelves or assembling cabinets, a tape measure for planning furniture placement in the space, a labeler for printing labels if you prefer this over handwriting, and a chair or kneeling pad to keep yourself somewhat comfortable as you plow through the clutter.

- **Other people** may be able to help you with the project, but enlist their assistance only if you believe it really will benefit you. If you're tempted to strong-arm them into helping because you resent having to do it all yourself, think again: Do you really want to make the process even more unpleasant by dragging in unwilling participants?

> **note** Sometimes, just having someone to talk to while you organize can be very helpful. We call this "social organizing"; it's a lot like the old-time quilting bees where all the ladies in the neighborhood got together to sew and chat. A friend who's there in person might feel obligated to pitch in (which could be good or bad), but a friend on the phone won't be able to, so he or she can provide guilt-free (and interference-free) company while you tackle your organizing!

If you are going to have helpers, you'll need to be especially careful in planning your organizing time. You will have to stick to whatever days and times you set, and if your helpers are not reliable, they might derail your intentions for that session. If some people have agreed to help you, your best bet is to be ready to work with them if they show up, but also to be ready to work alone if they don't.

Plan Your Time

This is where the meaning of organizing your home "in no time" becomes apparent: If you're like most people, you have "no time" to do this! How are you going to fit it in among all of your other responsibilities?

The trick is to do a portion at a time. Whether you prefer marathon, day-long sessions or an hour here and there, you'll get it done if you chip away methodically. If you overload yourself, you'll burn out and abandon the project, and if you try to organize your entire home in one day, you'll end up having to stop whenever you drop, not according to a plan that leaves you able to function without undoing your progress until you can get back to your organizing project.

Identifying Your Project Completion Style

Here's one way to customize your organizing time: determine whether your project completion style is sprinting or jogging. (This concept comes from Wilma Fellman's book *Finding a Career That Works for You.*) If you're a *jogger*, you tend to complete projects a little at a time, taking a steady pace and working in a more or less predictable manner. If you're a *sprinter*, you tend to work in bursts of energy, focusing your entire being on one thing for a short period of time and then walking away from it to regroup for a while. A jogger prefers to spend an hour or two each day working on organizing tasks; a sprinter would rather spend an entire day every week or two on the organizing project, and then ignore it completely until the next time.

Whichever you are, sprinter or jogger, don't try to change your style. Instead, embrace it, work with it, and make the most of it as you plan your organizing project. If you're a jogger, you might schedule one hour a day, three days a week, to work on organizing until you're caught up to the level that defines "organized enough" for you. If you're a sprinter, you'll probably do better to block out two weekend days each month and plan to do nothing else but organize on those days.

Estimating How Long It Will Take

Determining from the outset how long this project will take you is probably going to be rather difficult. It will depend on how often you're interrupted, how quickly you are physically able to work, and how quickly you make decisions.

Do one session, working efficiently but not racing, and assess how much you get done in that time. From there, you can generalize how much time the entire project is likely to need.

For now, set aside several consecutive blocks of time, and get ready to get started with purging in Chapter 5.

tip Observing yourself in this way can be beneficial for another reason: You might catch yourself taking too long to make decisions. Remember that decisiveness is a key principle in organizing: You must be able to make decisions, and do it accurately and quickly, if you're ever going to get through this!

Summary

You've got your first target organizing area, you know what you want that space to be used for, you're armed with trash bags and boxes, and you've got a general idea of what you're going to do to make that space match your vision. Move on to Chapter 5 and start clearing the clutter!

Let the Purging Begin

5

The moment has arrived at last—time to start getting rid of extraneous stuff!

Are you excited? Are you like that bouncy kid in line for the Easter egg hunt, barely able to keep yourself from dashing for your first acquisition?

Or do you feel more like you're on your way to the principal's office?

If you're delighted to start filling up trash bags and donation boxes, this chapter will be a breeze for you. If you're dreading it because you're already feeling deprived of things you would love to keep if only you had the room, this is going to be tough for you and you'll probably get rid of less stuff.

However you feel as you approach this process, let me give you a word of caution: Strive for balance. If you're rarin' to go, be careful not to go overboard. Enthusiasm for purging is a greatly useful attitude—just make sure you don't start tossing things you actually need or that someone in the household will be furious to lose. And if you'd rather be doing anything else, just try a little at a time, give yourself permission to mourn the things you're discarding, and keep the ultimate goal in mind: a neat, efficient, peaceful home.

Things You'll Need

- ❏ A table and chair
- ❏ Three containers for sorting
- ❏ Several more containers for collecting keepers by category
- ❏ A trash can or free-standing trash bag frame
- ❏ Large trash bags
- ❏ Labels and labeling markers
- ❏ List paper and pen/pencil
- ❏ A camera for before-and-after photos (optional)

Do a First Pass

The easiest way to start is to get the lay of the land with a first pass through the area you're going to organize. If you would like to document your progress with before-and-after photos, now's the time to snap your "befores."

Grab a trash bag and start plucking out trash. Get as much as you can spot. If you need to stop and get another bag, great! Keep at it until there is no more obvious trash in sight.

There are two great reasons to do this first pass:

1. It feels good to start by eliminating a chunk of stuff. You get to see progress right away, and you get stuff out of your way for the rest of the process.

2. You get into practice with seeing your belongings in a new way. What was once a landscape of unremarkable items, all blending quietly into one another, is now not one big glob but dozens or hundreds of individual items to be assessed one at a time. It's like walking toward a pointillist painting: What appears to be one fluid picture actually reveals itself, on closer exami-nation, to be a multitude of distinct, individual dots.

> **tip** Protect your back! Lift correctly, and fill containers and trash bags only as heavy as you can handle safely.

Don't be too analytical in this step. In this first pass, you're just doing a quick walk-through to catch the obvious discards—stuff you're probably wondering why you didn't toss in the first place. Don't stop to ponder whether or not to toss an item; if there's any question, leave it for the next step.

Some examples of the kinds of things you're looking for on your first pass:

- Empty shopping bags, boxes, and mailing cartons
- Wrappings and tags from purchases
- Fast-food bags, containers, and cups
- Wads of junk mail, coupons, empty envelopes, and old newspapers (yes, these are paper, but for this step you can treat them as objects)
- Boxes from purchases that you wanted to save until you were sure the thing worked and you weren't going to return it
- Trash that didn't make it to the trash can because you couldn't reach it or it was full
- Things that have gotten irreparably crushed, water-damaged, stained, torn, chewed, or otherwise ruined during their time in this area

tip "But I might need that." Those are perhaps the five most common words a professional organizer hears, and they're also the words most likely to keep you wading through clutter. If you're holding on to empty cardboard boxes, shopping bags, and other universal containers, what's the worst that could happen if you threw them all away? Boxes and bags come into our lives as reliably as sunrises. Don't hoard them.

If you hear yourself saying "But I might need that" about any item, make sure keeping it is really worth the effort of choosing a home and container, putting it there, labeling it, and remembering you have it if you do in fact need it someday.

Depending on the space you're clearing, you might also collect dirty clothes and dishes at this point and take them to the hamper or sink. If clothes are part of what you're organizing, however, just set aside the dirties to work through in the next step—no point in washing them first if you might end up throwing them away.

If you're really ambitious and a good multitasker, you might be able to collect items for donation in this step as well. Grab the obvious giveaways and put them in a box or a bag that's not the same type as your trash bag to avoid confusion.

When you've collected all of the obvious discards, it's time to give closer scrutiny to the remaining items.

tip Avoid tunnel-vision in the area you're organizing. Every space impacts the other spaces around it in some way. Anything you move from one area is going to take up space in another, and there are bound to be items in other areas that belong in the one you're organizing. Be sure to leave room to bring in more items that belong in the space you're working on, and take care not to overburden other areas in your quest to bring this area up to par.

Clear a Work Space

Do yourself a favor at this point and take a few minutes to create a comfortable work space within the area you're organizing. Take the time to get a table, chair, and trash bag holder—it will make the work so much easier! Set them up in the center of the space so you can reach them easily. A lot of people are tempted to skip this step because they see this project as so temporary that they don't want to "settle in." Please trust me on this: You'll have a lot less fatigue and back pain if you get a folding table to set things on and a chair so you can sit down once in a while. A large trash can or free-standing trash bag frame will also make a big difference because you'll be able to sort with both hands and toss things into the bag rather than holding it in one hand and having to maneuver it open each time you want to discard something.

note Which should come first, the purging or the organizing? This can be a chicken-and-egg question, but in general, it's difficult to create homes for your belongings before you really know how much you have in each category. This is why organizers usually recommend you eliminate things you're not going to keep *before* you go to the trouble of organizing them. However, if you're bound and determined to make your stuff fit your space and not the other way around, plan your homes first (you might want to peek at Chapter 6 for a preview), and then complete the sorting and purging in this chapter according to how much space you've allocated for each category.

Next, position three containers near your work table:

- One for items to donate to charity. Label it CHARITY, DONATIONS, or whatever word is most descriptive for you.

- One for items that you're not discarding via trash or donation, but that don't belong in this space. This can include items that go elsewhere in your home and items to be returned to people who don't live with you. Label this one KEEP BUT NOT HERE, GIVE BACK, or whatever works for you.

- One for items you're keeping that will stay in this space. Label this container STAYS HERE or something similar.

You can use any type of container for sorting—remember that these are just temporary receptacles to keep your categories from blending back together.

And what if there's no room in the space for a table and chair? You need room to work, so clear some floor space by temporarily boxing up some items and stacking them out of the way. Banker's boxes, as shown in Figure 5.1, are an ideal size for this purpose—they're small and light enough for most people to be able to lift and move, they're relatively inexpensive, and they're reusable. You can box items into rough categories if this seems easy for you, or just fill the boxes randomly; it doesn't really matter because you're going to go back to them very soon anyway.

Banker's boxes, like the typical one shown here, are ideal for temporarily containing some stuff to get it out of your way while you work.

If the space you're organizing is such that it would make more sense to locate your work area in another room, go right ahead. Perhaps you're working on the kitchen, and you can't have a table set up in front of the stove for days on end. Choose another area that is as close as possible to the kitchen but also out of the way of family activities, so your organizing work space won't have to be dismantled at the end of each session.

You might also choose to locate your work space outside of the area you're organizing if that space is so full that you can't stand to work in it or you're going to need to move boxes of items out of the space as you're clearing it.

DONATING ITEMS TO CHARITY

Many people want to donate discards whenever possible instead of just trashing them—it feels good to help others, and it takes the sting out of the money you lost on a purchase that didn't work out.

It's best to have a charity chosen before you start purging. That way, you know what their collection rules are, what they will and won't take, whether they pick up, and any other parameters that might impact what you set aside to donate and how you package it.

For simplicity, choose a charity that will take just about anything. Trying to sort into more than one charity box will add a layer of complication that you don't need. Use multiple charities (such as the library for books, one place for clothes, and another for household goods) only if you already have a relationship with them and you know you'll follow through with getting the stuff out of your home and car!

Also, try to choose a charity that has an after-hours drop-off bin so you can take things in at your convenience. If you use a charity that will pick up, be sure to follow through with calling for a pickup appointment and getting the stuff out to the porch if you won't be home. Avoid finicky charities whose pickup drivers will sort through your donations and leave anything they don't want on your porch. You made the effort to salvage some things for the disadvantaged; the last thing you deserve is another mess to clean up!

Although "beggars can't be choosers," don't treat charities as trash collectors. It's not fair to pawn off junk that you *know* is junk just to get rid of it. If you think an item could be useful for someone else, by all means, donate it! But know when it's only good enough for the trash.

Pitch instead of donate

* Clothes that are noticeably stained or torn
* Broken items
* Electronics that don't work
* Games missing crucial pieces
* Baby items that were recalled for safety issues
* Disposable items (such as margarine tubs)
* Unsanitary items (such as used cosmetics)
* Single shoes or gloves
* Anything hazardous (such as chemicals; be sure to dispose of them properly)

To do list

☐ Sort items into categories
☐ Decide what of each category you'll keep, and what you'll toss

Process Your First Category

Now that your work space is set up, it's time to start gathering items to be purged and sorted. Do you remember the organizing principle of "like with like"? You're going to apply it now!

"Like with like" means grouping similar things together. During purging, you do this for the purpose of making educated decisions about what to keep and what to discard. Working in categories instead of considering one isolated item at a time will

reduce any anxiety you might feel about the keep-or-toss decision: You can draw a conclusion about one particular black sweater with much more confidence if you're looking at all of your black sweaters at the same time.

Sorting Your Category

Grab an item from your work area. It can be anything—whatever catches your eye. Now ask yourself two things:

1. What is one category this belongs to? (There could be more than one.)

2. What other items from the same category are in this space?

Gather onto your work table as many items from that category as you can find. Each time you collect items, keep an eye out for trash and toss it! If you find that there are too many items in this category to consider all at once, narrow the category until it's manageable.

For example, "books" might be too much to handle all at once. Collect as many books as you can find, and then subdivide them in whatever ways make sense to you—fiction, nonfiction, and reference, for example, or "have read" and "not yet read," or "for knowledge" and "for decoration." Then consider each of the subcategories one at a time. This is also a good approach for categories that you find especially boring or irritating: Break it down into the smallest possible bites (kind of like those fried liver dinners from your childhood).

> **tip** Suppose you hit an item that has no other category-mates in your work area. Set it aside and group any other "loners" with it; then process this group as your last makeshift category.

Once you have a manageable group of items on your table, all members of the same category, it's time to consider each one and decide: Is it a keeper, or not? Make the choice and place it in one of your four containers:

1. TRASH

2. DONATIONS

3. KEEP BUT NOT HERE

4. STAYS HERE

Making the Big Decision: Keep or Pitch?

Clients around the world struggle with the decision of what to keep and what to discard. This just may be the single biggest reason there are professional organizers! Here's a simple way to choose:

Do you love it (not sorta like it, not used to love it, but truly love it right now)? Then keep it.

Do you use it (not is it useful, but do you use it right now)? Then keep it.

Are you obligated by law (not by guilt or other emotion, nor mother or other person) to keep it? Then keep it.

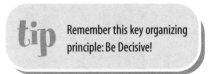

tip **Remember this key organizing principle: Be Decisive!**

If the answer to all of these questions is no, let it go!

Check out Figure 5.2 for a flow chart of the decisions of the purging process.

FIGURE 5.2

If an item is going to earn the right to remain in your organized home, it must make it through each of the following trials. How tough will your tests be?

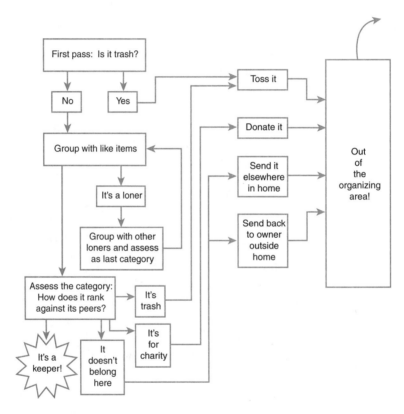

Don't obsess over finding every piece of a category before you begin. Gather as much as you can find with reasonable effort, and then just get started. If you encounter items later that are part of a category you've already processed, decide on them individually right then based on your memory of what you did with that category, or set them aside to do another round of that category.

Working One Category at a Time

After you've completed one category, collect and process another. Do this until you've sorted everything in your work area, and remember to do your group of "loners" last.

Empty your trash and sorting containers as they fill up and, if possible, remove the contents from your work area. Bag up the trash and make a pile by the door; you can take it all the way out at the end of your session.

Transfer the donations into bags or boxes for pickup or delivery to the charity. (Don't sacrifice your sorting box for this—use something else.) Do the same with things to be returned to people outside of your home.

As you work, watch your energy level. When you get fatigued, sleepy, achy, bored, overwhelmed, or otherwise miserable, stop! This is not boot camp. If you push yourself too hard this time, you'll always find a reason to never get back to it next time.

caution Purging can give you an overwhelming urge to drop everything and have a garage sale, but you must resist! Finish your organizing first!

Some caveats:

When you sell something in a garage sale or on eBay, the most you're likely to get back is 10 percent of the purchase price. Look at that cup in your hand. You paid $2.50 for it. Is it worth your time to try to resell it for 25 cents?

If you keep a bunch of stuff during purging in order to resell it, you're not going to see much organizing progress. You won't discard much of anything because it will all appear to have sales potential.

How badly do you want to reclaim your space and get your home organized? In the grand scheme of things, does a garage sale support your ultimate goal?

Calling It a Day

When you're ready to wrap up your organizing session, take a few minutes to protect your work and leave the area in a condition that will welcome you back and allow you to pick up right where you left off.

IF YOU HAVE NO DISCARDS...

What does it mean if you have very little in your trash bag and donation box, and your space is still over-full? Are the items still there because you couldn't decide, or because you want all of them? Do you look at the space as a whole and tell yourself you need to clear it out, but find you can't part with anything when considering items one at a time?

If you can't work through this by yourself and your own logic isn't enough to spur you into letting go of some stuff, consider talking to a doctor or therapist. Some conditions, such as some forms of obsessive-compulsive disorder, can make it very difficult to part with belongings, even when you recognize it's not in your best interest to keep so much stuff.

Here are some basic steps for winding up your day's work:

1. If you have piles or containers in progress, dash off a quick label for each. You might think you'll remember what you were doing—it's so obvious to you right now, in the thick of it—but why not leave yourself some reminders?

2. Maintain your "keeper" items in whatever order you've created for them so far. At the least, keep them grouped by category, and use basic containers or some sort of divider to keep the categories from merging again. If you're going to have a large number of items in the area when you're done organizing, and therefore you're accumulating a lot of keepers, box them in categories and label the boxes in detail. Then stack the boxes against the wall in your work area until you're done purging.

3. Consider how your organizing area will be used in between your work sessions: If it will be untouched, you can leave your keepers right where they are. If it's possible they might be disturbed, however, do what you can to protect your work from being undone between now and your next organizing session.

4. Right now, while it's on your mind, make a list of supplies and tools you'll need for next time. Do you need to buy trash bags? Are you running low on boxes? Write it down so you can get what you need *before* you need it.

5. Remove everything that no longer belongs in this area. Take the trash outside to wherever trash goes. Move donations to your car if you're going to drop them off, or if they're going to be picked up, put them as close to the pickup point as you can. Bring out the items that need to be returned to someone outside your home, and promise yourself you'll get them out (or at least ask the owners to come get them) before your next organizing session.

6. Relocate items that belong elsewhere in your home as close as possible to where they should be. Don't let yourself get upset about creating a bigger mess somewhere else: You're clearing one area at a time, and you'll get to the rest eventually. If the item already has a home, fabulous! For goodness's sake, put it away!

7. Finally, go back to your organizing area and take a good look. Enjoy surveying the progress you've made! If you're taking photos to track your progress, snap a few now and at the end of each work session. Also keep a mental picture of how the space is shaping up to give you something to look forward to with your next session: You're going to make it even better next time!

What Next? Organize Here, or Purge Somewhere Else?

At this point, you might be wondering what to do when you finish purging your first area. Should you organize that area before moving on, or should you keep purging your way through your entire home?

The answer is simple: Do whichever one you will actually *do*. Either way can work, so choose the option that's more likely to keep you interested and making progress. Some people love purging, and once they get a taste of it in the first area, they blaze through the rest of their home, purging everything they can and paring down their belongings to only those things that truly support them.

Others need to complete one area before starting another. They can't tolerate the idea of leaving loose ends throughout the house in the form of boxes of "keepers" waiting to be organized, so they finish one area at a time.

Consider just how much organizing you have to do overall. Is it your entire home? If so, trying to complete all the purging before applying organization will likely be too disruptive. If your disorder is confined to a few areas or is mostly in out-of-the-way storage spaces, you could purge every area and then go back and organize.

If you've got more purging to do, stay here in Chapter 5. When you're ready to start applying organizational systems, move on to Chapter 6.

Summary

Here's hoping you feel a lot lighter! You've completed at least one area of purging, which should mean you've generated a lot of discards and reestablished your connection with the belongings that are really important.

In Chapter 6, you'll work with your keepers to determine the best homes for them within your home.

Making Homes for Your Keepers

How did your purging go? Do your local charities now love you even more? Did you fill up the curb or dumpster with trash? Did you make your kids get their furniture out of your basement?

At this point you should have only keepers left in your organizing area. If you decided to purge your entire home before starting this chapter, by now you should own nothing that does not support you in some important way.

You've separated the wheat from the chaff and you've respected the belongings that are truly important by eliminating the ones that aren't. The riff-raff has left the building; now your home is VIP-only.

When you welcome honored guests into your home, you don't have them sit on the floor, do you? Of course not, and you should treat your honored belongings with the same consideration. That's what we're going to do in this chapter: Designate a home for every item, provide it with a proper container if needed, and make sure it settles in comfortably. Perhaps some of your belongings aren't homeless, but their homes could use remodeling! You can also use this chapter to improve areas that don't need full-scale purging

or that already have some organizational systems. If you took "before" photos when you started your organizing project, be sure to keep up with "durings" and—hallelujah—"afters"!

To do list

- ☐ Determine why items never seem to be in their designated homes
- ☐ Understand why some items always remain homeless
- ☐ Find homes for the items you'll keep in your organizing space
- ☐ Learn expert tips for finding the most useful home for any item

Deciding Where to Put Your Stuff

Now that you've purged unneeded items, you have a clearer perspective on your options for this space. With clutter out of the way, you can now actually *see* the possibilities. Take another look at your organizing area and do some more big-picture thinking:

- What is your plan for this space?
- Will you have enough room to use it for that purpose?
- Now that you can gauge how much space you actually have, is the amount of stuff you're planning to keep in here realistic? Is it still too much, or could you actually fit more than you planned?

If you think you should relocate more items to another area, now's the time to do so. Go ahead and pull out anything that won't be staying in this space, and move it as close as possible to where it should be. If you think you might actually be able to fit more stuff, wait. Organize the space and then add to it later if you really do end up with extra room.

To decide where you're going to put items within this space, give some thought to what makes an object's "home" good or bad. Think about your entire living area first, and then we'll narrow our focus back down to the area you're currently organizing.

Chances are you have belongings in each of these groups:

1. Those that have a home and are in it.
2. Those that have a home but don't get put away very often.
3. Those that have not been assigned a home.

Those in the first group are easy: They're done! Those in the second and third groups need further consideration.

Fixing Your System When Items Are Never in Their Homes

It's likely that these items aren't "living" in the right place. Try to determine why they never go home. Is the home too small? Do you have to climb stairs or take many steps to put the item away? Do you have to move other things to reach this item's home? Do you use the item too often to put it away?

Here's an example of something in a less-than-ideal home: my beach towels. I have a closet by the back door with a shelf that was for these towels, so they were easy to grab on the way to the yard and easy to put back after they were washed. We now have other plans for that closet, so I've relocated the towels to a steamer trunk in the same room.

The problem? The trunk is not quite big enough to fit all of the towels, so it's hard to close, and there is a small lamp on top of the trunk that must be set aside to open it.

There was one beach towel in the last round of laundry, and I put everything else away immediately (because everything else has convenient homes) but I left that towel sitting out for a while because I didn't feel like moving the lamp, fighting with the latch, and figuring out how to cram the towel into the trunk. I can already see I'm going to have to think of another option for beach towels.

Think about the things you own that technically have a place they belong, but they often don't make it there. What's wrong with the system? Set aside any self-blame ("I'm too lazy to put it away most of the time…") and look at this as a flaw in your system, not in yourself. Now, how could you relocate these items to make them easier to put away?

Choose better homes for those belongings that have been on "permanent vacation"!

Dealing with Homeless Items

Now consider those of your belongings that have never been given a place to live, or perhaps had a home in the past but now just hang out wherever they land. Think of one such item and ask yourself why it's homeless. Is it because

- You can think of more than one place it could go, and you can't decide which to choose?
- It's a loner, so there is no category of items to group it with?
- All of the places it could go are imperfect in some way (a little too small, a little too inconvenient)?
- You're leaving it out to remind you to do something?
- It's not something you ever planned on keeping? Remember, things that belong to others or are destined for removal don't need homes—they need to be evicted!

- You don't like it? This is an interesting phenomenon. When you receive a gift that you don't like for some reason (it's not the right color or style, it's not something you need, it came from someone you don't like, it was given as a passive-aggressive insult), don't you tend to leave it sitting out? That's because you didn't want to accept it in the first place, so you don't want to mix it in with the belongings you *do* like!

Whatever the reason, find a way around it and choose a home for each of your homeless items. If it could fit into more than one category, choose the one that makes the most sense and put the item with its mates. If it's a loner and there is no home that's more logical than any other, choose a home somewhere near where the item is used. You could even make a container for these odd-ball loner items and let them all live together.

If the surfaces of your home are one big to-do list, with items lying around to remind you to do some task...it's not working very well, is it? Make a list instead and put the items away somewhere.

These homeless items are the toughest organizing decisions you'll make. That's actually good news, because once you've decided about these things, the hard part will be done!

Finding Homes for the Items in Your Organizing Space

Narrow your focus once again to the area you're currently organizing. Of the items you're planning to house in this space, how many have you already chosen homes for and how many still need that decision?

You're at an important crossroads right now. You have the opportunity to organize this space in a way that will be ideal for you—efficient, functional, and complete. If you take the easy road and skip some of these tough housing decisions, you won't be organized enough. If you take the more difficult road and choose a home for every last item, your organizing will be complete and your system will serve you much better into the future.

Remember that an item's home can be changed whenever you like. You're not locking yourself into anything permanent when you choose homes. Try one way, and if you don't like it or it doesn't work, by all means, change it! Remember my beach towels—they're not going to live in that trunk much longer.

You can do it: Go the extra mile and give every item a home.

Tips for Choosing Homes

Here are some tips for deciding where an item should live, in the space you're organizing and throughout your home:

- Consider all of the storage spaces you have available: closets, cabinets, drawers, and shelves for smaller items and containers, and open areas such as a basement, attic, storage cage, garage, or shed for larger items and storage tubs.

- For categories of things that are used in more than one place, determine whether it makes more sense to divide the items among each of the spaces or to store them all in one central location. For example, would you rather divide all of your towels and toilet paper among each of the bathrooms, or keep them all in one closet and parcel them out from there? What about bed linens, trash bags, and cleaning supplies?

- For small things and categories with many items, it's usually best to use containers. Containers will allow you to stack, taking advantage of vertical space, and they allow quicker access because you can grab one container and not worry about knocking over a bunch of little items. Containers also help you to keep categories together and not rely on your memory to see the distinctions among a morass of items sitting next to one another. Leter sections go into more detail on container choices.

- Choose open or closed storage based on your and your housemates' visual preferences in combination with the other considerations listed here.

- Some items come with limitations that must be considered when assigning them homes. Is the item especially heavy? If so, an overhead shelf won't be safe, and any surface the item rests on must be able to bear its weight. Is it flammable, combustible, or corrosive? If so, it must be stored away from heat and flame, and it must be put in a container that will catch any leaks and will prevent it from mixing with other materials that could cause a dangerous reaction.

caution If you have children or pets, anything dangerous such as chemicals, medications, and weapons must be stored securely, for example in a locking cabinet or box.

- How often do you use the item? Frequently used items should be given the most convenient homes; if they're not, they'll never make it home. Don't just tell yourself you'll be more disciplined. Make the system work for you, not the other way around!

- What conscious tradeoffs are you going to have to make? Items will often have conflicting needs, and these must be considered when you assign homes. For example, if you own a handgun for personal protection or carry it on the job, you have two conflicting storage needs: safety and convenience. When not in use, the gun must be stored safely, which will mean extra steps

to access it, but when you do need it, you need it quickly. Don't just ignore these conflicts: Make conscious decisions on how to resolve them.

These tips give you some ways to make decisions about the trickier items. Now, be decisive!

Creating Space: Shelves, Cabinets, and Storage Units

Suppose you're converting a bedroom into a home office. The only built-in storage is the usual closet with one shelf and one hanging pole. You won't be hanging clothes in this room, so your only place to put stuff, as of now, is that single shelf. Clearly, you're going to need more storage space than that!

You can accomplish a lot with furniture, free-standing shelf units, and other portable storage options. In fact, you might be able to create all of the shelf and cabinet space you need with a combination of desks, shelving units, and storage cabinets, purchased either as finished pieces or as kits you assemble yourself. (You can even put a shelf unit or cabinet in the closet under that hanging pole!)

tip
If the space you're organizing needs repairs, do them now, before you put everything back in place! This is the ideal time to paint or wash the walls, clean or replace the flooring, or change or add outlets for electricity, phone, internet, and cable.

My favorite build-it-yourself line of furniture is Sauder (see Figure 6.1). Their products combine reasonable prices with good quality, making them an ideal choice for most people's budget and skill level. Sauder products are sold in many stores and are also available through catalogs. Shipping these heavy items is quite expensive, but it's good to know you have this option if you can't find that perfect piece in a local store.

FIGURE 6.1
Sauder is the leading manufacturer of ready-to-assemble furniture. Visit www.sauder.com for their line of products.

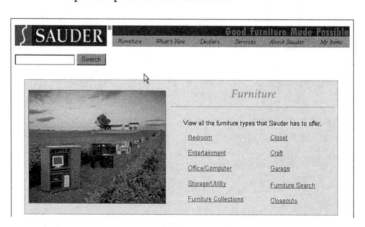

If you're willing to make more permanent changes to the space, you can hang shelves of whatever type, quantity, and configuration you want. You also have affordable options in modular storage systems. My favorite product for this need is Easy Track (www.easytrack.com; see Figure 6.2). Like Sauder, Easy Track combines affordability and ease of assembly, so it's ideal for most people.

Easy Track requires attaching one track (a piece of sturdy angle iron) to the wall. That's the hardest part—and that's pretty easy. Then you hang vertical panels from the track and attach shelves, clothes rods, drawers, or baskets in a variety of configurations to suit your needs. Because it's based on one bar at the back, it doesn't have to be confined to the inside of a closet: You could create a system on any wall.

FIGURE 6.2

This is one of the modular closet kits in the Easy Track line. The hanging poles can be replaced with shelves, and you can add drawers, baskets, and even doors to customize for your needs, making this system ideal for much more than just clothes storage. Visit www.easytrack.com for more options.

To do list

- ☐ Decide what material your containers should be made of
- ☐ Choose container sizes and shapes
- ☐ Decide when to use lidded containers
- ☐ Choose translucent, opaque, or colored containers
- ☐ Find the right price

Choosing Containers

Even with plenty of drawers, cabinets, and shelves, you need some containers to keep small things together and to allow for stacking in order to make the best use of vertical space.

When I start working with a new client, I often find that he or she has quite a selection of containers available to work with. Usually, though, they're not exactly what we need or there is something inferior about them. The following points will help you to purchase the right containers for your needs.

Things You'll Need

❑ Various containers, depending on the items to be organized

❑ Labeling supplies, if you choose to label

❑ All of the keepers that belong in this space, including furniture

❑ A camera (optional)

What Should It Be Made Of?

In most cases, it's best to choose a container made of plastic.

Cardboard is never appropriate for long-term storage. It attracts insects and pests, loses its shape and strength relatively quickly, and absorbs moisture, leading to mold, mildew, and odors.

Boxes made of wood or metal and baskets made of soft materials can be okay in some applications, especially for attractive storage on a countertop. Again, though, these materials are not the best for long-term storage. Wood can have the same problems as cardboard, depending on the species and construction, and soft materials such as fabric and baskets are not impervious to water, dust, or insects. Metal can be damaged by water as well, and its edges can scratch you and your surfaces.

In general, plastic is the most versatile, long-lasting, and trouble-free material for storage purposes. Be sure to choose plastic containers that are well-made, not brittle or flimsy. Rubbermaid's products are excellent: They're sturdy, yet the plastic remains flexible enough to not shatter if dropped or exposed to cold temperatures (see Figure 6.3).

FIGURE 6.3
Rubbermaid makes a wide variety of high-quality storage containers. Visit www.rubbermaid.com for more information.

What Size and Shape Should It Be?

Standard sizes will be easiest to stack with other containers, so they're generally a better choice. Choose containers that are only as big as you can handle safely. Consider what you will be storing in the container: When it's full, will it be too heavy for you to lift? Wheeled containers can help with this problem, but sooner or later you'll probably have to lift it. Whenever possible, choose a number of smaller containers instead of one huge one that will injure your back.

Perhaps the handiest container is the shoebox size. If you put your mind to thinking in categories, you could probably purchase at least a dozen of these and use them up immediately.

Note that this is not the same as packing to move to a new home. The goal is not to use the least number of boxes and pack them as tightly as possible. While it's true that you should try to avoid "storing air" by using a large container for just a few items, it would be worse to break up a category just to fill a box. Use the smallest container you can, and graduate to a larger one if the category grows, but always keep your categories together, even if it means storing some air.

Does It Need to Have a Lid? What Kind?

Open boxes and baskets are often more beautiful than functional, but you can find some that serve both purposes, such as those offered by Lillian Vernon (see Figure 6.4). The main downfall to un-lidded containers is that you can't stack more containers on top of them.

tip
If you're looking for an attractive container for use on a table, countertop, or other highly visible spot where you wouldn't stack containers anyway, a beautiful open-top basket might be just right.

Lidded containers come in a wide variety of styles, including fully detached lids, lids that are hinged on one side, and lids that are split down the middle and hinged on opposite sides. Consider what the container will be used for: Will the lid make it harder to access? Do you need the lid to be attached (sometimes a good idea for kids' toys) or will it be a nuisance?

Put the lid on and take it back off. Does it open easily enough? Watch out for sharp edges that might cut or pinch you if you have to apply force to pop the lid open.

caution
Avoid domed lids—you can't stack on top of them!

FIGURE 6.4
These beautiful baskets from Lillian Vernon are ideal for a shelf or desktop where you don't need to stack multiple containers. Visit www.lillianvernon. com for this and other products.

What Color Should It Be?

Choose opaque containers if you prefer closed storage or if the items you'll be storing should be protected from exposure to light. The containers can be any color, but avoid very dark colors if you intend to label them by writing on them with a marker.

Choose translucent or transparent if you want to be able to see the contents without opening the container. Sky-Rail is my favorite clear container system (see Figure 6.5).

FIGURE 6.5
Sky-Rail is a professional organizer's dream: The fully transparent "pods" stack to make maximum use of vertical space, and the built-in rails let you pull one out without making the ones above it drop. Visit www. sky-rail.com for a demo video and ordering information.

How Much Should It Cost?

Storage containers shouldn't cost a fortune. Avoid cheaply made containers, but also avoid ridiculously expensive ones. You can find good-quality containers at reasonable prices in stores like Meijer, Wal-Mart, Kmart, and Target.

After you've become familiar with which containers are good and which are subpar, you might also check discount and "dollar" stores for deals: They often have the shoebox size and sometimes even larger. Just make sure the quality is adequate.

There are also stores that specialize in storage systems, tools, and containers, such as Hold Everything and The Container Store, and websites such as Stacks & Stacks (www.stacksandstacks.com), Lillian Vernon (www.lillianvernon.com), and Solutions (www.solutionscatalog.com). These are excellent sources for special needs such as safe storage for fine china or unique kitchen items.

> **tip** You'll sometimes end up with empty containers when you change your system down the road. Don't discard them: It's good to keep a few containers in common sizes on hand for future use. But keep only materials that are meant for repeated use—don't save cardboard! Store empty tubs, boxes, and other containers upside-down so you can easily tell which are available for use.

Summary

Now you know what to do with your keepers! You've learned why belongings sometimes become homeless and how to prevent it, you have new options for built-in storage, and you know what to look for when shopping for that perfect container. You are officially ready to put your stuff away, so go to it!

If you have trouble at this point, look to Chapter 7 for solutions to some common organizing problems. If you sail through, head to Part 3, "Maintaining Your Progress."

Help! This Is Too Hard!

onsider this chapter a rest stop on your road to organization. If your organizing has left you drained and even a little disheartened, if you're finding the process more difficult than you expected, or if you need some techniques and encouragement for overcoming common obstacles, do as any weary traveler would: Pull over, stretch your legs, and recharge.

In this chapter, I'll help you deal with that unpleasant sensation of being in over your head that most people experience at some point when they undertake a large organizing effort; I'll also help you figure out how to stay focused and not get off-track every time you try to get some organizing done; and I'll help you talk yourself through the difficulty of letting go of things when it all seems like good stuff or when you have a reason to love every item.

To do list

- [] Break organizing tasks into individual steps, and tackle one at a time
- [] Accept that organization can be difficult to achieve, and pace yourself to maintain progress without burnout
- [] Learn to make decisions that help simplify the organizing process

I'm Overwhelmed!

"Ow, my brain hurts!"

My clients constantly express this sentiment; the words vary, but the pain is the same. It stands to reason that if you have a lot of catching up to do in the organization department, you're probably not naturally good at it or you're tremendously out of practice, so jumping in and doing a lot all at once will hurt just as much as if you suddenly hoisted yourself out of a sedentary lifestyle and tried to run a marathon.

Over-exercising causes muscle pain. Over-organizing can cause you to become overwhelmed by the multitudes of decisions required of you when you start an organizing project.

As you learned earlier in this book, clutter = homeless items = unmade decisions. Therefore, organizing requires catching up on all of those unmade decisions at a pace and quantity that you're not used to. Just as running builds up your physical fitness, organizing enhances your intellectual fitness by honing your ability to make quick, accurate decisions. Also just like running, in the beginning, organizing often hurts.

There can be many reasons that decision-making is difficult or painful for you. You can overcome many of them all by yourself, just by thinking through why you're having trouble and giving yourself some techniques for making the process more tolerable. The following are some ways to refine your organizational training program to make it manageable for the long haul.

Things You'll Need

- ❑ Cardboard tissue or towel roll
- ❑ Hula hoop
- ❑ Boxes for sorting

One Step at a Time

Organizing is often challenging for global thinkers—people who see the entire picture all at once and sometimes have trouble seeing its parts. Remember the comparison to pointillist painting in Chapter 5? From a distance, a pointillist painting looks like a smooth sweep of colors and shapes, but it's actually composed of millions of tiny dots. The artist must think about each of those dots individually before he or she can produce the "big picture," literally. The same is true for you as you produce your organizational masterpiece.

Look for ways to break this project down into smaller sections. Even if you've already done this to some extent, do more. Make the bites smaller and smaller until they're chewable!

It can really help to break off pieces not just in planning, but in a visible way. Judith Kolberg, author of *Conquering Chronic Disorganization,* suggests using the core from a roll of paper towel or toilet tissue as a spyglass to segregate a manageable portion of work: Complete only what you can see through your spyglass, and when that area is done, scope out another. (Hint: Step closer to the pile to narrow your field of vision.)

Another tool to make a visible boundary is a hula hoop. Yep, you get to go to Toys R Us and buy an organizing tool! Toss it into the space and work on only the items within the hoop.

If you're purging items already in boxes, focus on just one box at a time. Ignore the other boxes: Choose one and tell yourself you can stop after you finish this single box if you want to. When you're done with that box, stop if you wish, or do another one. Ironically, giving yourself the option of stopping each time will usually give you more energy to continue.

No matter what or where you're organizing, find ways to break the project down into smaller steps, and focus on just one step at a time. You'll be surprised at how far you go before you stop again to check your progress.

Respect the Difficulty of the Task

Many of my clients chastise themselves for needing my help. They say over and over, "This should be easy—why can't I just do this? How pathetic that I need to hire someone to help me with something so basic!"

The truth is that organizing is not easy and basic for everyone, and it doesn't diminish you in any way if it's not within your skill set. Stop beating yourself up and acknowledge that what you're doing here is difficult. It's intellectually and often physically exhausting, and it takes a time commitment to catch up on a backlog of clutter. It's not something you can just fit in "in your spare time"—if you could, you would have already.

Pay attention to which areas seem harder than others. You might find that you don't mind de-cluttering closets, but you despise working in the basement. Or perhaps you can handle anything but paperwork—very normal, because paper organizing is far more time-consuming and decision-intensive than organizing objects.

Give yourself mental space to recognize just how challenging this can be. When you do, ways to make it easier and ideas for pacing yourself will present themselves.

Make "Metadecisions"

The prefix "meta-" in front of a word signifies a higher order or global perspective on the word that follows. For example, metafiction is fiction written with the intention of not only telling a story, but demonstrating something about the act of fiction-writing itself. A metalanguage is one developed for the purpose of explaining or

analyzing other languages. You practice metacognition when you think about your own thought processes—which means you're doing it right now!

A *metadecision*, therefore, is a decision made with the intention of impacting or replacing a number of future decisions. Metadecisions are crucial to organizing because they save you the mental anguish of making thousands of individual decisions one by one.

Think of metadecisions as rules you can blindly follow when an applicable situation arises, making it easier to just do what you need to without intellectualizing every step.

For example, take margarine tubs. Perhaps you save them to reuse for leftovers, art supplies, or other household needs. That's a normal, frugal habit. The problem is that it can be tough to know when to quit with margarine tubs. You saved the first one because it was inherently useful, so what's to stop you from saving every one that comes into your life from here on out? Where do you draw the line?

This calls for a metadecision. Without even looking at your stockpile of margarine tubs, decide on a maximum number you will keep. It could be 10; it could be 3; it could be 0. The important thing is that you choose a number and stick to it. From now on, you won't need to make a decision about every margarine tub you encounter, because you have a rule: X margarine tubs live with me, and when I have saved that many, I won't save any more. Then, and only then, choose a home for your margarine tubs and put your chosen quantity in that home. As you run across more stashed away in cupboards, you can mindlessly discard them—no further decision-making needed, because your single metadecision is working for you.

> **tip**
>
> Why did I tell you to decide how many margarine tubs to keep without looking at your existing supply? Because you already have enough information about this category to make a decision without revisiting (and possibly re-bonding with) each individual tub. You know what a margarine tub looks like and what sizes you buy, you know what they can do, and you know what you tend to do with them. So, pick a number and set it firmly in your mind.

Use metadecisions to breeze through organizing any category in which you tend to save multiples and often ask yourself, "Do we really need this many of these?" It's especially effective with categories of things that are inherently useful—not only margarine tubs, but also plastic grocery bags, empty cardboard boxes, pieces of bubble wrap, and even socks and underwear—and that tend to grow to unmanageable quantities if left unchecked. Make a metadecision on the maximum number of these categories that you will keep.

Why work through the decision-making process hundreds of times when you could make one metadecision and be done with it? If you embrace this concept, I promise your organizing will become much easier.

I Can't Stay Focused!

Ah, distraction—the bane of every project!

As I'm writing this section of the book, there are gas company workers here moving my meter from the basement to the outside of the house, and one of them just scratched my car; my cats won't stop crying for food even though it's nowhere near dinner time; the neighbor two doors down seems to be playing with his new lawn-mower because it couldn't possibly be taking this long to mow one tiny little yard; and best of all, I'm working standing up with my computer monitor and keyboard on platforms because a recurring back problem has made it too painful to sit for any length of time.

Can't stay focused? You and me both! Use the bag of tricks I've listed here to help you retain your focus, and eventually you'll be done! Bonus: You might find your new concentration skills spilling into other areas of your life where they're also needed!

To do list

- ❏ Learn to use an "anchor" to help you remain focused
- ❏ Jot down "distraction tasks," rather than letting them interrupt the flow of your work
- ❏ Make the decision to ignore phone and email distractions
- ❏ Divide multiple tasks into separate, multiple sessions
- ❏ Reduce environmental distractions
- ❏ Make the most of high-energy periods

Things You'll Need

- ❏ Pen/pencil
- ❏ Note paper or sticky note pad
- ❏ Fan, radio, and organizational tools, as appropriate

Use an Anchor

In organizing parlance, an "anchor" is another person who helps you to stay on track. It can be anyone from a paid helper to you yourself. The key to anchoring is that this person's presence reminds you to stick with what you're supposed to be doing when you become distracted.

For some people, just having someone else there with them is anchor enough. The person doesn't have to be interacting with you in any way; in fact, it's better if he or she doesn't. Your anchor needs to be aware of what you're trying to concentrate on, and you need to know that he or she is quietly watching your progress. The anchor's presence serves as a physical reminder of what you're doing so you don't go off and start doing something else!

If you want to try asking a friend to be your anchor, instruct the person to simply sit still in the same space as you work. The anchor should not participate in the work, and absolutely must not give suggestions or comments about what you're doing. The anchor also must not distract you with conversation if it will cause you to slow your pace. The anchor can choose to perform a quiet, unrelated task if it won't distract you, something like knitting or scanning a magazine.

note Being an anchor can be difficult: It requires sitting relatively still and keeping your mouth shut for an extended period of time—two things a lot of people have a hard time doing!

You can anchor yourself by thinking out loud. Yes, it sounds funny sometimes, and another person walking in might tease you. But it works! My clients often think out loud when I'm with them. I don't tell them to; they just do it naturally. And they're not really speaking to me. They're speaking to themselves, but because I'm there, attending to the same thing they're attending to, it feels natural to them to speak their thoughts. Recruit someone to be your anchor, or just start talking to yourself: Either way, you'll find it easier to keep your thoughts directed toward your organizing.

Capture Fleeting Thoughts

Doesn't it sometimes seem like your mind has a mind of its own?

Despite your best intentions, if your mind just doesn't feel like going along with the organizing, it will throw one unrelated thought after another in your path to try to get you to do something, anything, other than what you're doing right now. This is one of the toughest types of distraction for me, and once I figured out a solution, my productivity soared.

When I'm doing something that doesn't fully engage my attention, especially something relatively mundane but time-consuming or something I don't really enjoy, I find myself bombarded with mental exclamation points: Call a mason for the chimney! There's laundry waiting! You need to pay bills! The cats' claws need trimming! Put shampoo on the shopping list!

Many of these to-dos are quick and easy, so I'm tempted to go do them while I'm thinking of it. It would feel good to finish something in the midst of working on a big project whose end is not yet in sight. Equally tempting is the occasional flash of a brilliant new idea that I so badly want to start right this minute!

But, like any human, if I do that, I'm liable to think of another quick and easy thing to do while I'm thinking of it, or spend hours playing with my brilliant new idea, and before I know it, the day is over and I didn't make any more progress on my project.

This is one major way that projects such as organizing get put off.

My solution captures the thought but doesn't allow it to distract me from what I need to be doing right now. I simply keep a pad of Post-its and a pen nearby, so I can scribble those exclamation-point thoughts and stay glued to my project until it's time for a truly necessary break.

When I stop for the day, I gather up my Post-its, do a few of the tasks if time permits, and add the rest to my to-do list, to be accomplished when it's time for them and not during project work. Yes, it sometimes takes the fun out of creative thinking, but it also prevents the agony of day-before-deadline all-nighters.

Keep a pad and pen near you to jot down any thoughts you want to pursue but which would interfere with your organizing if you did them right then. It could be to-dos, new ideas, resolutions—anything that your mind concocts to relieve itself of the burden of what you're making it do!

Ignore the Phone and Email

When you're trying to get something done, the phone and email are NOT your friends! Get into the habit of outright ignoring them in favor of continuing on with your project. Resist the urge to let someone rescue you from the discomfort you might be feeling when that phone rings or you hear "You've got mail!" from the other room. Putting off your organizing won't get it done!

This is another place where a metadecision comes in handy. Set parameters for when you will check email (for example, once at lunchtime and once at the end of the day; NOT first thing in the morning) and for when you will let the answering machine take your calls (for example, I'll work on this for two hours and then check messages). You can screen calls with Caller ID if you're afraid you might miss a true emergency.

It can be disorienting to not respond to an incoming phone call or email. If you're used to jumping for them, it feels very strange not to. Trust me: This reactionary lifestyle is not serving you! Break this habit and take better control of your time.

> **tip**
>
> I am definitely not a slave to a ringing telephone! I don't want to miss an emergency call, but if I answered every ring I'd never get anything else done, so I created an "emergency alert system": My voicemail tells callers that if they're having an emergency, they can call back immediately and I'll answer if I hear the phone ring twice in a row. Boy, do I chew them out if they abuse this system!

Don't Multi-Task

For those who are at all distractible, multi-tasking is like communism: It sounds like a good idea in theory, but in practice it's usually a disaster.

If you're trying to stay focused on your organizing, doing laundry, meal preparation, bill-paying, or other household tasks at the same time will provide you with endless ways to get off-track. Multi-tasking makes it very easy to slip away from a project that you're not really enjoying anyway.

Instead, work on your organizing in shorter sessions. It's easy to rationalize interspersing laundry and cooking if you intend to spend eight hours on your project, but if you set out to complete just two hours, multi-tasking suddenly seems like the distraction that it actually is.

If two hours is still too long, make it one hour. Make it 15 minutes if that's all you can tolerate for now; 15 minutes is better than none. It will take you more days to complete your project, but the alternative is never getting through it at all.

Fix Environmental Discomfort

Here's one I point out to clients all the time, and they're always surprised—they're so used to dealing with an uncomfortable environment that they don't even notice it any more.

What's it like to work in the space you're organizing? Check on these points:

- Lighting. Is there enough light to actually see what you're doing? Take a black garment and a navy blue one into the space: Can you see well enough to distinguish the colors? If not, bring in a lamp or two to temporarily brighten up your workspace, and add more lighting later to make the space usable.

- Temperature. Is it too warm or too cold? Is it stuffy? Make yourself as comfortable as possible by using a space heater or fan, or opening a window.

- Odors. Is the space musty? Does it smell like pets, dirty clothes, or some other unpleasant aroma? Open a window if possible, and use air freshener, a good dose of cologne on your chest, or even a swipe of Vick's Vapo-Rub under your nose to quell the smell. Remove whatever odor-causing items you can, such as trash cans, laundry, or the cat's litterbox.

- Cleanliness. Is the space dusty, water-damaged, moldy, or otherwise dirty? Some areas, such as garages and basements, are just dirty by nature, and there's not much you can do about it until you clear out excess objects and make some room to deep-clean. In the meantime, protect your lungs with a mask or even a respirator depending on the severity and nature of the pollutants that are present. Wear goggles to keep dust and debris from landing in your eyes, and make sure your footwear protects your toes and is thick

enough to prevent puncture wounds if you step on something sharp. Wear gloves, long sleeves, and pants if the space is not unbearably hot to prevent insect bites and contaminants touching your skin, and avoid touching your face or rubbing your eyes. Take a shower and shampoo your hair as soon as you're done for the day to rinse away contaminants and prevent spreading them throughout your home.

- Energy. When's the last time this space had light and movement in it? Spaces that have been closed up for a while are filled with stagnant energy, and working in them can quickly drain you. Get the air moving with an oscillating fan and play some bouncy music at the highest comfortable volume to liven things up. As you clear the clutter, your own energy will disperse into the space and you'll feel it gradually lighten.

- Your clothes and tools. Are you wearing oversized or too-tight clothes and shoes with no arch support that you save for dirty jobs? If you have long hair, does it fall into your eyes every time you bend over to pick something up? And speaking of picking things up, are you remembering to bend at your knees instead of your back? What about the table and chair you're using: Are they fairly comfortable and sturdy, or are they rickety, too small, and, honestly, inadequate for what you're trying to use them for? Make yourself as comfortable as you can, and give yourself the right tools for this job.

Take a bit of extra time to make your work environment more pleasant: It will pay off in the long run.

Capitalize on Peak Energy Times

If your organizing project has any hope of being completed, you're going to have to make it a priority, and that means giving it some of your best time. If you're a morning person, schedule some organizing sessions for first thing in the morning, before you start your day. If you're a night owl, plan to spend some time before bed working on organizing. If you have extra energy on the weekends, do your organizing then; if you spend Friday night through Sunday night on the couch, don't kid yourself: You know you're not going to get up to organize, so plan to squeeze it in during the week and leave your weekend for vegetating blissfully uninterrupted.

But It's All Good Stuff!

This can be a tough thought process to break out of. If you can see the inherent usefulness of just about anything but you can't temper that usefulness with the inconvenience or even illogic of keeping every item, you're bound to have trouble with excess stuff.

The fact that you can think of a way to reuse just about anything doesn't mean you *should*. And it definitely does not mean that you *will*. You can have every intention of reusing all the gift wrap that you carefully remove from packages, fold, and tuck away somewhere, but if you don't actually do it, all you've accomplished is adding clutter to your home.

Clients who are experts at seeing the potential in every tote bag, button, and unmated sock present a special type of challenge for a professional organizer. We can't argue with you when you say you could use that bag to carry workout gear, and the button could be useful if you lose one, and the sock could be made into a puppet. You're right! But the fact remains that you've got more stuff than you can manage, so something has to give.

If you find yourself rationalizing the salvation of just about everything you encounter in your organizing space, ask yourself these questions:

- What's the worst that would happen if I let this go?
- How much will it cost if I toss this and then end up having to buy one?
- If I save this, what's the likelihood I'll remember I own it and be able to find it when I need it?
- Do I have anything else that already serves this purpose for me?
- Is there someone else who needs this more than I do?
- Is it really in that great of shape? (If it would be too shabby to give as a gift to someone else, why is it worthy of you?)

Use these questions to outwit your own over-productive logic and make progress on your clutter-reduction goals.

ARE YOU AFRAID OF DEPRIVATION?

Being comfortable with owning only what you need and love requires a level of physical and emotional security that not everyone has. Are there reasons why you have to worry about not having access to what you need when you need it? Is this true of your current situation, or was it true in the past?

People tend to hoard more in times of transition and grief, because they don't really know what they're going to need once life settles down again. The uncertainty of these times can also be threatening to your belief that you can provide for yourself and don't need to stockpile things "just in case."

If your life is in upheaval right now and you're finding it hard to let go of belongings, it might be best to hold off on de-cluttering until your transitional phase is completed and you're better able to gauge which belongings you need.

To do list

- ☐ Understand why you feel compelled to keep certain objects
- ☐ Learn to deal with feelings that might complicate the organizational process
- ☐ Keep your collections manageable
- ☐ Make organizational decisions based on your wishes and needs

It May Be Worthless, But I Love It!

These are the tearful scenes you sometimes see on the organizing television shows—the client cries as the "professional" rips some treasured item from their hands.

We won't be doing that in this book!

Loving a worthless object becomes a problem only when you don't have enough space or energy to care for it. When the object's perceived needs are in conflict with your own, or when its existence is creating a problem for you—a problem that is greater than the value you receive from it—it's time to put yourself first and let it go.

However, knowing that won't necessarily make it easy and pain-free.

The following are some reasons we become overly attached to our belongings and some ways to break unhealthy attachments.

note This might seem hard to believe, but 80% of everything is basically useless. Seriously! There is a rule called the Pareto Principle that has proven, in hundreds of contexts, that only 20% of any category of items is actually used, while the other 80% serves only to keep dust off the surface beneath it. Think about your and your family's clothes, shoes, CDs, kitchen utensils, books, toys, tools, and hobby supplies. Does the Pareto Principle hold true for you?

Letting Go of Objects You Love to Touch

Kinesthetic sympathy, identified by National Study Group on Chronic Disorganization founder Judith Kolberg, is what happens when you touch something and reactivate your positive feelings toward it. Items that feel or smell good, such as clothing, textiles, or stuffed animals, are likely to provoke kinesthetic sympathy.

Kinesthetic sympathy short-circuits your ability to make an objective decision about the item. To prevent it, make your decision *before* you touch the item. Look at it from a few steps away. Have a helper hold it up if necessary. If it is an article of clothing, hold it by the hanger without touching the garment itself. You should find it easier to let go if you're not literally holding onto it!

Realizing You Can't Hurt an Object's "Feelings"

Anthropomorphism is the assigning of human qualities to inanimate objects. Like kinesthetic sympathy, this provokes an emotional reaction and interferes with your ability to make objective decisions.

We tend to anthropomorphize anything with a face: Dolls, stuffed animals, even sculptures. If you "feel sorry" for an object, you're anthropomorphizing.

Try making your decision without looking at the front or face of the object. Remind yourself that it is not human and does not have feelings. If you can't get away from feeling sorry for it, ask yourself if there is someone who would give it a better home—perhaps you can pass it on.

Remember, you're not in this life to be the custodian of your belongings. They should support you, not the other way around.

Coming to Grips with Sentimental Attachments

If it's not kinesthetic sympathy and it's not anthropomorphism, it might just be plain old sentimentality. The item reminds you of something good, so you keep it in order to keep that memory.

There is nothing at all wrong with this! Again, it only becomes a problem if the quantity of items has become unmanageable for you.

Check your sentimental favorites for items that could be converted in a way that retains the memory but loses the bulk. A great way to do this is with photos. Are there some three-dimensional items that you could take a photo of, and then pass on the actual item? Many sentimental treasures are likely to be meaningful to others in your family; perhaps a relative (in another household!) would like to have the item.

Managing Collections

Collecting is a hobby that can get out of control organizationally. The idea of a collection is to collect as many of the things as you can, right?

Yikes—recipe for clutter!

If there is something you collect, here are two guidelines to help you keep that collection manageable:

1. Be very picky about adding to your collection. Don't just grab anything that fits the category. Select only items in excellent condition that really add something new to the group. Avoid near-duplicates, items of inferior quality, or items that are not a stellar representation of what you're collecting. One of the factors that makes a collection high-quality is the collector's discerning

choices. Anyone can breathlessly buy every Beanie Baby in sight, but it takes research and patience to acquire only the most important, most exemplary Beanie Babies.

2. If your collection is too large to display all at once, rotate the items. This prevents your home from becoming a museum for your collectibles, and it keeps the collection fresh and interesting. If you have, say, 100 pieces of Swarovsky crystal, display only 10 at a time and store the other 90. Periodically, put those 10 away and bring out 10 others. Guests will be interested in seeing your collection each time they visit, because there will always be something new to see, and you will still have room to live!

ARE YOU SURE YOU LOVE IT?

People often keep things out of a sense of guilt or responsibility.

Did your parents will it to you, and so you feel compelled to be its guardian? Did someone spend a lot of money or go to a lot of trouble to provide you with this thing, and so you feel obligated to keep it and to think highly of it?

Is this really what's best for *you*?

Give yourself permission to let go of things you don't really love.

Putting Yourself First

It can be easy to put the perceived needs of our belongings before our own. When you know you need to reduce your clutter but you hesitate to discard something for any of the reasons in this chapter, it's likely that you are neglecting what's best for you.

Remember, there is room in every life for some sentimental items, some things you just love for no practical reason, some fun stuff, and some excess. You don't have to be monk-like in your reduction of clutter, but you do need to make a conscious choice—a metadecision—to keep only those items that truly serve you somehow. In this way, you demonstrate respect for yourself, for your space, and for the objects.

Summary

How do you feel? I hope this chapter helped you to identify and move past any discomfort or trouble you were having with your organizing so far. Now we'll head into Part 3, "Maintaining Your Progress," beginning with Chapter 8, "Organizing While Life Goes On."

Part III

Maintaining Your Progress

Organizing While Life Goes On

O rganizing your home "in no time" means fitting it into your everyday life. It's hard enough to carve out multiple blocks of time for the initial steps of de-cluttering and creating homes. Few people can devote many hours on an ongoing basis to organizing! You probably don't even take the time to sleep or exercise as much as you should, so any organizing you're going to accomplish from here on out will have to be quick, easy, and within the parameters of your regular routines.

By the way, if you're thinking perhaps you need to organize your time, too, check out another book in this series: *Organize Your Family's Schedule In No Time* by Valentina Sgro.

At this point, you've cleared your clutter and assigned homes to the remaining treasured and needed items. Now you need systems for holding the ground you've gained and also for making changes as needed down the road, and that's just what you'll find in this chapter.

Things You'll Need

- ❑ The pictures you took in Chapters 5 and 6
- ❑ Paper and pencil or your computer for list-making

Take Stock of Your Accomplishments

Before you go any further, take some credit!

Sit down and list what you've accomplished so far. Go into detail: How many bags of trash did you discard? How many bags of donations? How much square footage have you reclaimed?

If you have de-cluttered and assigned homes in more than one space, make a list for each. If you took before and after photos in Chapters 5 and 6, compare them. What a difference, huh?

Take a minute to appreciate how far you've come! If others in your family worked with you, do this together or share your lists with them so everyone can see how much progress has been made.

Not only will these lists make you feel good, they'll also serve as a starting point for your maintenance plan from this point forward. Keep your lists and photos together: You might want to make a file folder for them, or collect them all in a large envelope. Organizing will be an ongoing project for you now, even if all you ever need to do is maintenance, so these notes and photos will remain important even years into the future.

> **tip**
> Do this even if you're not done with all of your organizing projects. As soon as you finish one, you must take conscious steps to maintain it, or the space is in danger of sliding back into chaos.

To do list

- ❑ Remember to use the organizational principles you've learned in this book as part of your maintenance plan
- ❑ Devise systems for maintaining your organization

Add Systems to Put Your Organized Spaces into Motion

A space where everything has a home and there are no extraneous objects is like a beautiful car with no motor. It looks great, but it's not yet ready to run.

When you've cleared the clutter from a space and designated homes within that space for the remaining items, it's time to add systems that will take the area from looking great to actually functioning. This is a critical preparatory exercise for when you stop admiring the room and start actually using it, meaning the items here will be taken out and used, new items will come in, and activities will be performed that might prompt changes to your initial plans for the space and its contents.

Use what you've learned from the eight organizing principles mentioned throughout this book to create the organizational systems you need.

Following the Organizational Principles

Let's review the principles again, this time with an eye toward how they will inform your systems design.

- Have a Home: Remember this principle and immediately choose a home for any new item that you bring into the space. Once you internalize this rule, it will begin to enter your thoughts even before you bring an item home. You'll find yourself in a store considering a purchase and asking yourself, "Yeah, I like it, but where would I put it?" Congratulations—you are officially on-board with the "homes" way of life!

> **note** "Homes thinking" will also short-circuit any tendency you might have to dump and run: You won't find it as easy to just drop an item in this space. When you get used to your belongings having homes, it will bug you when one goes homeless for any length of time.

- Like with Like: You've assigned homes logically, often based on categories or the item's function, so whenever you acquire something new, chances are you will already have one or more logical places for it to live. If you did a thorough job in Chapter 6, "Making Homes for Your Keepers," you will already know any new item's neighborhood and will just have to choose the right house.

> **tip** Remember, "Like with Like" will also help you to be discerning about what will and will not be allowed to come into your newly organized space. You will find it relatively easy to add only items that belong there because they are like the items already in the space, and you will reject dissimilar items because they don't fit the plan for the space.

- Contain It: A big part of staying organized is making sure your belongings don't become excessive again. One way to do this is by using your containers (boxes, bins, drawers, shelves, and so on) as a boundary. When the container for a particular category becomes full, it's time to do some purging and/or stop acquiring new members of the category.

- Go Up: This principle reminds you to always make the best use of vertical space. When storing items, this means stacking and using containers to fill empty space within cabinets and shelves.

- Be Systematic: Being systematic means using metadecisions and universal theories to lead you to solutions without having to think through every facet of the question. It puts you in an active role as the keeper of your belongings and gives you power over how they fit into your life and, by extension, how new items might or might not fit in as well.

> **caution** When operating within a room or area, the Go Up principle can be used to remind you of one very important guideline: Don't put stuff on the floor! If you're considering the floor for the home of anything other than heavy furniture, even "temporarily," beware: You might be on the brink of a poor decision.

- Get Organized Enough: Lest you begin to take being systematic too far, also remember the importance of being "organized enough": Make your organization only as complex as you need it to be, in order to function optimally.

- Make Conscious Trade-offs: You made conscious trade-offs when you purged unneeded items and chose homes for those you kept. You can continue to use this guideline as you choose what new items will or won't make it into your household, and how much change and inconvenience you're willing to tolerate to keep yourself organized. In many cases, you will choose between time and neatness.

- Be Decisive: All of my emphasis on decisiveness has, I hope, shown you just how many decisions you're faced with all day long, and just how quickly a mess will pile up if you delay making those decisions. With anything you're considering acquiring, whether at a store, in a flea market, or as a gift, ask yourself, "Is this destined to become future clutter?" Once you've made a decision, stick with it. If you put a system in place, don't second-guess it: If it works, use it, and keep using it until it stops working. Then upgrade it and move on!

> **tip** Hesitate before you buy something new. If you can't immediately think of an urgent need for the item *and* what its home will be, hold off. If you really want it, it will stay in your mind; if it was about to become yet another impulse purchase, the thought will quickly fade and you will have avoided creating a new problem for yourself.

MATCHING SYSTEMS TO CIRCUMSTANCES

Be aware of how and why you do what you do, and find new applications for the organizing techniques and decisions that work well for you. Why reinvent the wheel every time you need a solution? For example, I employ a number of sorting techniques. I know that alphabetizing works well for me, so I've alphabetized my CDs and DVDs. Books, however, are grouped by genre or subject, because these factors are usually more relevant to me than the author's name. When the color of the items in a category is the most important thing about them to me, I organize by color: My shoes, socks, and clothes are arranged in color order. (So, yes, I can get dressed in the dark and not end up wearing one black sock and one blue one.)

Now, suppose I took up scrapbooking. I would make a conscious decision about how to organize and store the multitude of tools and supplies I would acquire to support this hobby. I would likely find applications for sorting by color and also by subject, and alphabetizing would probably play a role too. The point is that I wouldn't start from scratch figuring out how to organize this new group of stuff: I would systematically build on what already works for me.

Another part of being systematic is remaining mindful of what you own. This lets you avoid buying the same item again or buying something that is similar in appearance or function. This is incredibly useful in keeping toys at a sane level: If you're aware that the kid has a toy that does pretty much the same thing as the one he's whining for now, your resolve will remain stronger as you say "no."

Devising a System That Works

You have endless options for the organizing systems you'll add to your household and your daily life. To find the right ones for you, start with your goals for the space, account for any parameters or limitations you've identified, and use the eight principles to decide how best to manage that space.

A "system" can be very simple; in fact, it should be! If you can't explain a system in one sentence, it's probably too complicated. Here are some examples of organizational systems in my home:

- Laundry: Dirty clothes go into one of three hampers, labeled according to the temperature in which they'll be washed: "Towels, Socks, Undies—Hot," "White and Light-Colored—Cold Light," and "Jeans and Dark-Colored—Cold Dark." (I don't split hairs with laundry: Why bother with warm?)

- "Clerty" Clothes: "Clerty" clothes (not exactly clean but not yet dirty, for example pajamas) are allowed to hang out on a particular chair in the bedroom.

- Recycling and Returnables: Empty bottles go on the back edge of the sink until someone makes a trip to the garage and puts them in either the recycling bin or the returnables can. (There is only room for about 10 bottles, so this space serves to cue us to when to empty it.)

- Shoes: Shoes are put on shelves in color order so I will know what color they are, even in a dim closet.

- Mail: Junk mail, outer envelopes, and mailing inserts go immediately in the trash; bills go in the bill-paying box in the office; magazines stay on the kitchen counter where I read them during breakfast and lunch.

- Toys: Toys live in two cabinets in the living room, in no particular order as long as the doors will close. (Yes, even professional organizers know to pick their battles!)

- Trash Cans: I keep a supply of trash bags in the bottom of each can, under the bag in use, so a fresh bag is always right there.

- Household Hardware: I have a set of shelves in the garage with about 16 clear plastic shoeboxes labeled according to the small household parts they hold: "Plumbing" (pipe tape, small fittings, washers), "Electrical" (a few switches, switchplate covers, electrical tape), "Automotive" (touch-up paint, replacement bulbs), "Locks and Safety" (padlocks, cabinet stops, outlet covers [notice these could also go in Electrical]), and so on.

My systems make life easier—simple as that. Yours will too.

To do list

- ❑ Choose a general plan for combining maintenance and organization
- ❑ Determine your maintenance steps
- ❑ Decide whether a schedule is right for you

Creating a Maintenance Plan

Getting organized has three stages:

1. Clearing the backlog of clutter

2. Creating homes for kept items and systems for staying organized

3. Keeping it together with maintenance

The following sections offer options for constructing and following a maintenance plan that will help you protect the organization you've accomplished as you move on to organize new areas.

Things You'll Need

☐ Pencil and paper

Coordinating Organization and Maintenance

People often intimidate themselves with the belief that all of stage 1 must be completed throughout the home before stage 2 starts, and all of stage 2 must be completed before stage 3 starts—kind of like a concert with three acts.

Organizing does *not* work that way! For your organizing to "stick," you must protect your past progress while working on new projects. Introduce maintenance for a space as soon as you've completed its homes and systems.

Suppose you want to organize your kitchen, family room, and garage, in that order. If you wait until the garage is done to begin maintaining the kitchen and family room, you will have missed your maintenance window: You will most likely encounter backsliding in the family room and especially the kitchen. *Backsliding* is what we organizers call it when a space has been neglected past the need for routine maintenance and now needs actual re-organizing to recover its ideal state.

Choosing a Maintenance Plan

The following tables offer three different plans for maintaining organization as you move on to organize new areas. The "time span" in each can be any length of time; the point is how the tasks in each area occur concurrently.

Option 1: Purely Step by Step

	Area 1	Area 2	Area 3
Time Span A	De-clutter	(no organizing)	(no organizing)
Time Span B	Homes & Systems	De-clutter	(no organizing)
Time Span C	Maintenance	Homes & Systems	De-clutter
Time Span D	Maintenance	Maintenance	Homes & Systems
Time Span E	Maintenance	Maintenance	Maintenance

Option 2: De-cluttering and Homes & Systems Done Together

	Area 1	Area 2	Area 3
Time Span A	De-clutter, Homes & Systems	(no organizing)	(no organizing)
Time Span B	Maintenance	De-clutter, Homes & Systems	(no organizing)
Time Span C	Maintenance	Maintenance	De-clutter, Homes & Systems
Time Span D	Maintenance	Maintenance	Maintenance

Option 3: All De-cluttering First (Only Recommended If You Have Relatively Little De-cluttering to Do)

	Area 1	Area 2	Area 3
Time Span A	De-clutter	(no organizing)	(no organizing)
Time Span B	(no organizing)	De-clutter	(no organizing)
Time Span C	(no organizing)	(no organizing)	De-clutter
Time Span D	Homes & Systems	(no organizing)	(no organizing)
Time Span E	Maintenance	Homes & Systems	(no organizing)
Time Span F	Maintenance	Maintenance	Homes & Systems
Time Span G	Maintenance	Maintenance	Maintenance

Identifying Your Maintenance Steps

After you've devised a plan for doing maintenance even as you continue bringing other areas up to par, you might wonder, "Just exactly what do I have to do to maintain?"

You can answer that question better than I! Simply look at what you've put in place, think about what you had to do to get it there, note what it's going to take to keep it that way, and anticipate potential problems before they interfere.

To create a series of maintenance steps, you go through an "if/then" process of anticipating and solving potential problems before they even happen. Follow this model with each area you organize and you'll put yourself into a self-sustaining loop of maintenance!

Identifying Obstacles

For example, suppose you've organized your bedroom closet: You grouped your hanging clothes into "work" and "non-work," and you put all of your shoes on a back-of-the-door shoe rack to optimize space. Now, what will it take to maintain this system? You might say

- "When I hang up a piece of clothing, I will put it either on the 'work' side or the 'non-work' side."
- "When I take off a pair of shoes, I will hang them on the shoe rack."

And what might interfere with these plans?

- You don't always hang up your clothes promptly. Maybe they need to be washed or dry-cleaned, or maybe you prefer to let your clothes and shoes "air out" for a bit before putting them back in the closet. The result? Dirty and "clerty" clothes and shoes lying around the bedroom and bathroom.
- You sometimes change your clothes in a room other than the bedroom.
- You're not the one responsible for the laundry, and the person who is puts all of your clean hanging clothes in one open spot in your closet.
- When you take your shoes off, it's because you're tired and your feet hurt, and the last thing you want to do is bend over, pick them up, and carry them to the bedroom to be put away.
- You have some shoes that don't make sense in the clothes closet, or you kick off your shoes as soon as you step through the door, so they rarely make it to the bedroom with the others.
- You might run out of hangers or spaces in your shoe rack.

Devising Steps that Overcome the Obstacles

Aha! Obstacles identified! Now, what can you plan to do about them?

- "I will put a hamper in the most convenient possible spot and work on developing the habit of putting dirty clothes in it immediately."
- "I will work on thinking of the bedroom as the place where clothes belong, whether or not I change there. If I change in another room, I will get into the habit of immediately taking my clothes to the hamper, 'clerty' spot, or closet."
- "I will hang 'clerty' clothes on a hanger, on a hook on the door. When I go to hang something else on that hook, I'll know it's time to move the first item back into the closet."

- If you don't do the laundry: "Whenever I notice that new laundry has been added to the closet, I will take a minute to separate it into the 'work' and 'non-work' sections."

- "I will still kick off my shoes as soon as I come in, but I will work on developing the habit of carrying them to the bedroom each night before I go to bed."

- "I will notice which shoes don't belong in the clothes closet (such as dirty gardening shoes, hiking boots) and give myself time to think of a better solution for them, while I work on maintaining the system I made for the shoes that *do* belong in the clothes closet."

- "I will leave a handful of extra hangers at one end of the closet, and every time I buy a new pair of shoes, I will get rid of a similar, worn-out pair."

And most important of all:

- "I will pay attention to what works and what doesn't with my new system. When I find a problem, I will tweak the system to make it better suited to my needs. And I will remember that no system will work if I don't use it."

> **tip**
>
> Gather all of your "I will" statements for this area. Write them out in list form, and add the list to your organizing paperwork and photos. If you ever forget what was supposed to be happening in this space, you will have your initial thoughts to refer back to.

Determining Whether You Need a Schedule

Do you need to commit to doing maintenance on the same day every week, or at the same time every day? No! If fact, trying to do that is likely to result in failure.

A strict, time- and date-specific schedule is extremely difficult to fulfill, so it should be used only for tasks that truly need it. The only household-related exception I can think of is changing your clocks for Daylight Saving Time. Other than that, a day here or there isn't going to have consequences of any significance.

Although your home doesn't need a strict maintenance schedule, *you* might need one in order to get the maintenance done. You can test this one of two ways: You can start with a detailed schedule and relax it later if you find you don't need it, or you can start with a more relaxed approach and if it doesn't work, apply a more detailed schedule. Choose the option that you think will work best for you.

TRY "CONSTANT ORGANIZING"

For some, responding to cues that were built in when they created their systems is enough to keep them on track with maintenance: When a container or space gets full, it's time to purge or perform a task. When you see something out of place, put it back. In their book *ADD-Friendly Ways to Organize Your Life,* Judith Kolberg and Kathleen Nadeau compare regular maintenance and de-cluttering to the way a restaurant server works, bringing new dishes to the table and clearing dirty ones at the same time. Leaving the clean-up to do at the end, as a separate step, would not be acceptable: The table could quickly fill up with dirty dishes, baskets, glasses, and condiments, making for a cluttered, unpleasant environment. Think about it: The same is true at home! Leaving maintenance for after you're done with whatever else you're doing (yeah, and you'll be done when?) turns it into a much bigger job that is very easy to never get around to. Think of reorganizing, cleaning up, straightening up, tidying, or whatever you prefer to call it as an integrated part of the process of using the space. When you operate this way, you will rarely need to set aside time specifically for maintenance, because you'll be doing it as you go.

Organized A to Z Enough

If you feel the need for a time- and date-specific schedule for some maintenance tasks, go ahead and write one. Don't assign the tasks to a specific minute on a specific day; instead give yourself a time range. Treat it like an appointment for utility service ("we'll be there somewhere between noon and 4 p.m."), not a dental cleaning ("be here at 3 p.m. sharp or you're bumped!").

> **note** It doesn't matter how you get your maintenance done, as long as your system works and you can sustain it into the future.

If this schedule works for you, congratulations! You've found the right system for you, so keep it! If not, make changes until it does work, or take another look at the "constant organizing" approach outlined above.

Introduce Change Gradually

"Habits take time to take root. Be patient with your developing habits, as you would with a seedling garden."

Earlier in this chapter, you might have noticed me using the phrase "work on developing the habit of" as a suggestion for your self-talk. I didn't tell you to simply say "I will do it."

This is because change is a process, not an event. You're human, and you're not likely to be able to make every change "cold turkey." Even with the best of intentions, you'll sometimes forget and do things the old way out of habit.

If you proclaim, "From now on I will do it this way," you've given yourself an ultimatum. Now what if you break your own new rule? Will you punish yourself? Will you call yourself a failure? Will you decide it was a dumb rule anyway and reject it?

What good will any of those responses do you?

Getting organized brings a lot of change into your life. It's for the better, of course, but that doesn't make it easy to absorb. Your mind needs time to transition out of one habit and into a new one. It takes practice and repetition, just like learning a new language or sport or musical instrument. To give yourself the best chance of succeeding, introduce new systems and behaviors gradually—give yourself time to fully internalize one or a few concurrent changes before you add more.

By the same token, give the people you live with time to settle into new routines and to get used to the changes that your organizing has introduced. It might take them even longer to get into new habits, especially if they weren't closely involved in the organizing process and/or don't have a personal stake in the outcome. You might have to answer, "Where's the …?" much more often for a while; remember that it's a small price to pay for the benefits you've gained.

Habits take time to take root. Be patient with your developing habits as you would with a seedling garden.

If you find that you are still impatient with yourself, consider the possibility that, deep down, you're still judging yourself for becoming disorganized in the first place. In your heart of hearts, you believe you should have been doing this all along, you should have been able to figure it out for yourself, and you're embarrassed that you needed to clear a backlog of clutter in the first place, so you're sure as hell not going to let it fall apart again!

Stop it. Condemning yourself this way is not helping! What you did in the past is *in the past*! So let it go. The changes you're introducing now will carry you farther from your old ways with every new day.

Show some mercy for the person you were back then, and detach from that person and his or her failings. If you believe people can improve themselves over time and deserve the chance to prove it, give yourself the same courtesy you would anyone else. You did the best you could with the knowledge and motivation you had at the time.

Summary

Now you know what to do to maintain the organizing progress you've made! In the remaining chapters, I offer you more tips on living your organized life, including a preview of ways to handle some special situations that might arise. Chapter 9, coming up next, continues our maintenance theme to help you embrace your new, organized lifestyle.

Embracing Your Organized Lifestyle

When your organizing moves from active systematizing to maintenance, things get much easier, but they also have the potential to fall apart from neglect. Don't let this happen to your home! Hold tight to your initial enthusiasm and keep finding new solutions as problems crop up. Enjoy the process of continually innovating to keep your overall organization in tip-top shape!

This chapter helps you to anticipate and tackle some common organizing danger zones. Your home will probably have some of these, and maybe even all of them! Head them off before they become huge problems, and prevent them from threatening your newly organized household. In this chapter, you'll also find special consideration of the unique challenges you and your family members might be living with. We discussed these issues in-depth in Chapters 1 and 2; here you can continue to apply what you've learned.

In this chapter:

* Managing exceptions to your "rules"
* Defeating common danger zones
* Refreshing your understanding of each person's unique challenges

To do list

- ❑ Cement your new organizing systems with real-life practice
- ❑ Adapt for special problem areas such as floors, horizontal surfaces, and drop spots
- ❑ Remember to respect each family member's right to have a say in the fate of their belongings
- ❑ Practice "constant organizing" throughout the day
- ❑ Tackle purging and storage of tough categories such as toys, clothes, and food

Dealing with Danger Zones

So much of organizing sounds great in theory...and then you try to apply it to real life and hit a brick wall. This section highlights some common danger zones you're likely to encounter and ways to head off trouble before it happens.

Things You'll Need

- ❑ More trash bags
- ❑ Various storage containers
- ❑ Patience and perseverance

Keeping Floors Clear of Clutter

Ah, gravity! So dependable, so consistent! If you drop something, you can always count on gravity to carry it straight to the floor and keep it there—which would be wonderful if the floor were where the thing *should* be. As we've learned thus far, however, the floor is rarely the right place for an item.

Think about all the floors in your home. How's the clutter level overall? Is it worse in some spaces? What keeps floor clutter from happening in the areas where it doesn't (if you have any such areas)?

Focusing Your Efforts

Floor clutter is perhaps the most dangerous and most inconvenient of all clutter, so it makes sense to make defeating it a high priority. I even have a name for this movement: Anti-Floor Clutter, or AFC. As with everything else, though, you have to pick your battles. Divide floor clutter into three categories according to priority. You can

call them red, orange, and yellow; or 1, 2, and 3; or A, B, and C; or "Mom Freakout," "Mom Growling," and "Mom Quietly Frustrated"—whatever names work for you.

The first type of floor clutter (Red, or 1, or A, or Freakout) is that found in places where floor clutter absolutely must never happen. Focus the majority of your AFC energy here. Examples include stairs and landings (both indoors and out), hallways, foyers, sidewalks, driveways, and any place you might have to walk through in the dark.

The next level is places where floor clutter is really inconvenient or unsightly. Make these your second-highest AFC priority. These tend to be the paths between doorways in any room of your home, and also the paths from the doorway to the main destinations in the room, such as from the bedroom door to the bed or from the bathroom door to the commode (in other words, the areas of the floors that get dirty fastest). Outside, this would include porches, decks, and balconies, and, in many communities, the entire front yard.

Finally, note the lowest-priority AFC areas, which tend to be along the walls and against the furniture. De-clutter them if you can, but remember that the higher-priority areas should always get your attention first.

Now join your organizing comrades as we rally in the streets shouting "AFC Forever!" (Okay, maybe just say it to yourself....)

Selling It to the Family

AFC might make your heart swell with enthusiasm, but your spouse and kids might just roll their eyes. How do you secure family buy-in?

- Let them know you'll only hound them about the top two types of floor clutter: The absolute no-no areas and the ones that really look bad or cause a lot of inconvenience. The lowest-priority floor clutter will be tolerated somewhat.

- Remind them that the main reason for the AFC movement is safety. People trip, fall, and injure themselves at home with alarming frequency. If you think it will help, tell them the horror story of the professional organizer who, at age 5, played jump rope in a cluttered room, landed on a sharp object, and nearly severed all the toes on her left foot. Yep, that was me: They saved the toes (although one is paralyzed), but I still have a big scar, a harrowing story, and a valuable life lesson.

- Warn that if you end up doing it for them, the items might go in the trash and will not be replaced quickly, if at all. I say "might" to avoid empty threats: With "might," you can decide with each incident whether to stash the item in a hiding place for a while, donate it to someone who will appreciate it more, or just chuck it.

- Ignore floor clutter that they want you to tend to, such as dirty laundry. Pretend it's not there. Wash only those clothes that are in the spot designated for dirty laundry (hamper, pile in the basement under the laundry chute, and so on). If your spouse has to run out and buy new underwear or your kids have to suffer the embarrassment of wearing dirty clothes to school, so be it: Perhaps they'll learn to put dirty clothes where they belong, or (gasp!) start doing their own laundry!

- Set a good example. Don't create floor clutter of your own!

De-Cluttering Horizontal Surfaces

Any open, flat space will tend to accumulate clutter. Why? Because it's so darned convenient! Good ol' gravity assists once again in this scenario, keeping objects from floating off the surface upon which they're lounging.

You might gaze at your jam-packed countertops and yearn for a clear expanse of shining, uninterrupted, *House Beautiful* space, but if you're like most people, as soon as you create

note Gravity was identified by Isaac Newton, as you might recall, and he's also responsible for Newton's First Law of Motion, which says, "An object at rest tends to stay at rest." Sounds like Sir Newton knew a thing or two about clutter!

that little slice of paradise, someone (maybe even you) will come along and junk it up again. Sometimes it can even seem like stuff moves there all by itself. It is possible to clear a space and keep it that way. It just takes maintenance, practice, and the occasional ruler across the knuckles. (Okay, not that last one, although I bet it would be effective.)

Train Your Brain

You've trained your brain to be accustomed to clutter, and you can train it to be accustomed to a lack of clutter. Once you're used to seeing a surface clear, any object encroaching on that space will jump right out at you (visually; hopefully not physically) and you'll feel compelled to put it away or holler for someone else to.

Say you have a table next to your favorite chair, for example, and it's always covered in stuff: the TV listings, a couple of books, some magazines, a few pens, a box of tissues, your reading glasses, a coaster that may or may not have a glass on it, a candy dish, and a big lamp in the middle. It's been like this for as long as you can remember, so if you were to come home and find nothing but the lamp on your table, you'd be nonplussed. It would just look *wrong*. You might like it looking clear, but at the same time you'd feel as if something was just not right. This is your brain processing a number of changes all at once.

Now, if you left the table like that—just table and lamp, table and lamp, day after day, table and lamp—eventually you would get used to it. If you then came home to find it covered with pens and tissues and magazines and candy, you would no doubt say something that ends in an exclamation point.

Congratulations! You've retrained your brain!

Make It Not-Flat

Every home has drop spots—the kitchen counters, coffee table, dresser tops, dining room table, even those little half-walls so often built just inside the front door—and these can make it really challenging to keep your horizontal surfaces clear. To remind yourself and everyone else not to drop in those spots, make them not-flat with something decorative and kind of delicate, such as a silk flower arrangement. No one, not even a kid in full-blown home-from-school rowdiness, is likely to drop something on top of a flower arrangement.

 note Old habits die hard: The entire family will probably need reminders like these for quite some time before uncluttered surfaces begin to look "right."

Keep It Moving

"See a penny, pick it up…" and the same goes for a shoe, book, piece of mail, Hot Wheels car, empty bag, the dog's leash, Grandma's Tupperware, and so forth. If you treat maintenance as a special event to be performed once a week or so, instead of a process that is constantly in motion throughout each day, you will be less likely to keep up the organizing progress you've made.

If you prefer your home to have a constant level of organization every day rather than one perfect Sunday afternoon followed by six days of gradually increasing chaos, perform little organizing tasks as you notice the need. When an object lands on a horizontal surface, don't let it stay there any longer than it needs to. Don't become obsessive, like the woman I know who makes her husband's side of the bed when he gets up for middle-of-the-night bathroom breaks, but do try to make maintenance of your organizing systems part of your routine all day, every day.

Maintaining Enclosed Spaces

When an object is stowed behind closed doors, its organizational priority automatically drops. "Out of sight, out of mind" definitely applies here. When you can't see the mess, it's so easy to forget it exists!

The good thing about clutter in enclosed spaces is that it's *contained*. You can tackle one space at a time with relative ease and avoid being overwhelmed by an entire room of clutter. This is a great way to get small children involved in organizing too: A 5-year-old isn't capable of picking up his entire bedroom, but he can put his books all upright on one shelf.

RECOVERING WITH BABY STEPS

It's normal for enclosed areas to backslide while the ones in plain sight are maintained, so skip right past feeling guilty about it and just go ahead and fix it! Take one drawer in the kitchen at a time, or one shelf in the linen closet, or one dresser drawer. Little by little, you'll bring things back to right.

Even professional organizers have to do this from time to time. I just took all the clothes out of my closet and corrected some creeping disorganization that started one night when I was sick and didn't have the strength to lift one hanger after another into its rightful place in the closet, so I just shoved everything off to both sides and put the new batch all together in the middle. Then a few days later I picked up a big load of dry cleaning and stuck it in the middle too. Voilà! Out-of-order closet! But easy enough to correct, so no harm done.

Clearing Storage Areas

You can think of areas traditionally used for storage such as basements, attics, garages, and sheds as super-sized enclosed spaces. The same dangers apply here, but on a larger scale. Resist the temptation to offload clutter into these spaces to be dealt with "later."

Storage areas tend to be dimly lit, making it easy to dump stuff in them and unpleasant to spend a lot of time clearing them out again. Don't create future work for yourself; if you feel the need to stash boxes and bags of miscellaneous stuff in random corners of the basement or as far as you can push them from the top of the attic stairs, consider the bigger problem: You probably still have too much stuff!

Anything that goes into one of these areas should be properly contained, labeled, and stacked neatly for easy future access. *Never* toss stuff in trash bags, cast-off cardboard boxes, or plastic grocery bags into such a space, telling yourself you'll remember what it is. You *won't* remember, and chances are it will be damaged by the time you retrieve it.

note Need more incentive? Here's a fascinating insight from feng shui theory: The basement is believed to represent your past, and the attic represents your future. A cluttered basement will tend to keep you bound to the past, unable to move forward, while a cluttered attic will block your progress into the future. Either way, you're stuck in a rut!

Identifying Off-limits Areas

There are some spaces that should always be empty. Among these are the top-priority AFC areas such as stairways and halls. Also leave a wide berth around the furnace, hot water tank, and anything else with a pilot light. Off-limits spaces are easy to organize, because there should be nothing in them—no exceptions.

Another set of spaces that should be designated off-limits is the space between a door and the wall. Okay, you might be able to get away with hanging a robe or even an ironing board on the back of a bedroom door, but try not to because it's a slippery slope: Put one thing there and others will migrate to join it, and pretty soon the door will only open halfway.

And that's the problem: Every door should be able to open fully. If it's blocked, even a little bit, by stuff behind it, it will make the space feel smaller and could cause injuries (such as a painful doorknob-in-the-hip bruise), and it could even impede escape or rescue in the event of a fire.

> **tip**
>
> Look around your home and identify every area that should be off-limits for any belongings. Be creative—what could go wrong?—or simply work from memory. Have you ever seen what a dog can do to Legos? Or what those Legos can do to the dog a day or so later? Yeah, I'll never have a problem remembering to leave at least two feet of clutter-free space around the dog's crate from now on.

Keeping an Eye on Drop Spots

I mentioned drop spots earlier, but I want to give them their own section here to make sure they get your attention. Everyone has drop spots, and you know where yours are. Mine are my desk, the floor on the passenger side in my car, and the kitchen counter. These are the places I have to be especially diligent to maintain. Why are they such a special problem? Because I have legitimate reasons for the initial drop in each of these places.

The desk is where all paperwork goes to be processed. This is a more time-consuming task than, say, putting away clean towels, so it tends to pile up. The floor in the car is where I toss empty envelopes when I open my mail at stoplights and where the balled-up fast-food bags go until I get home (or maybe until I clean out the car a few days later). The kitchen counter is where everything coming into the house gets set down and then redirected. So, at first, putting things in these places is okay. It's when they don't move on that it becomes a problem.

Among the drop spots that torment my clients:

- The floor next to the bed
- The foyer
- The bathroom floor

- The dining room table
- The laundry room or mudroom when it's the primary entrance
- The front floor, back seat, and trunk of the car
- Under the desk
- The kitchen counters
- The coffee table
- Next to, under, or behind the couch

Identify your drop spots and look at them with a fresh perspective. They're not just spaces where your organizing ability is nil. They might be serving a purpose; if so, you just need to be more intentional in their use, more aware of when the drops have accumulated past your point of tolerance, and put systems in place to have managed drops, not free-for-alls.

Managing Communal Spaces

These are also known as "nobody's job spaces" or "everybody's job spaces," which are the exact same thing because (as you know if you've ever worked in a place with a break room that was the employees' responsibility to maintain) when it's everybody's job, nobody does it. Or the same disgruntled person does it every time.

In your home, the most likely communal-management space is the family room. Everyone is supposed to share responsibility for keeping this room picked up. And who actually does it? Usually Mom. Sorry, not to be sexist, but that's the way it is.

Unless your family is more cooperative than the Brady Bunch (and remember they had Alice), making anything "everybody's job" is not likely to work. Assign it to someone; rotate it if everyone hates doing it; but make sure someone—one specific person—is held accountable for the space. That person can choose to put everything away (both their own stuff and everyone else's) or they can ride herd on the rest of the family to make them each pick up their own things from that space, but either way, there should be one person whose job it is to make sure that space stays neat.

And, Mom? Make it someone other than yourself!

Taking Care of Tough Categories

For our final danger zone, let's shift from thinking in spaces to thinking in categories. Some categories of items tend to be more problematic than others, for a variety of reasons.

Toys

Could anything be more heartrending than trying to separate a child from a toy? Zoom in on the tear-stained face, the little hands clutching the treasured item. Seems cruel and utterly unnecessary, doesn't it? Now pan out to a wide shot of the room, with the tyke standing amid a sea of treasured items—hundreds of them, and each evoking a plaintive wail of "That's my favorite!" if you try to add it to the donation box.

You're right, it's really unfortunate that it got this way in the first place. It's going to be tricky to whittle it down to a manageable number of toys, and my hope is that once you've navigated this minefield, you'll emerge with a much more discerning attitude toward incoming new toys.

My best advice on this one is that you know your child best, so only you can decide what can go without too much upset and what absolutely must stay. I caution you, though, that if you want to sneak items out a few at a time, you should hide them away somewhere for a few weeks or months until you're sure they haven't been missed. The only thing worse than taking a toy from a sobbing child is telling the sobbing child that you already threw that toy away.

caution Don't hesitate to throw away broken toys; in fact, you might reach the point where you're *glad* to see a toy break so you can get rid of it! When it no longer functions safely, has sharp edges, or is so filthy that it poses a health hazard for the child, you can make it go away guilt-free

Clothes

Keeping clothes clean and organized is an ongoing challenge for many people. Remember conscious trade-offs? If you're drowning in dirty laundry, now might be the time to trade tons of clothes and tons of laundry piles in favor of fewer clothes and laundry that's more frequent, but with much fewer loads.

If you have trouble letting go of clothes, kinesthetic sympathy might be to blame. (I explained this in detail in Chapter 7, "Help! This Is Too Hard!") Try deciding before you touch the item.

Like toys, kids can also form strong attachments to their favorite clothes, again creating emotional scenes when you try to separate them. You can use "broken" as a reason to discard clothes, just as you do with toys: Clothes that are too small or too stained or holey to wear can be considered "broken" and weeded out with a clear conscience.

tip If an article of clothing is too precious to discard, even when it's outgrown, make a pillow or wall hanging out of it, save it in a memento box, or use the material in a quilt or scrapbook.

School Stuff

School is by definition a period of transition, and it's hard to let go of things during transitional times. Artwork, essays, report cards, uniforms, sports gear, and musical instruments all tend to accumulate and one year blends into the next if you don't apply some structure.

Choose a timeframe (for example, one semester or one year) to contain school stuff. After that timeframe has passed, sort and weed out everything school-related. Save the best artwork and other examples of your child's growing knowledge and abilities; eliminate (and replace if necessary) uniforms and gear that no longer fit or are worn out; file documents such as report cards by child and/or by date.

If the school allows students to keep their textbooks, help your child to make good choices on what to keep (for example, introductory texts, such as algebra, that will be built upon in future classes) and what to eliminate (such as completed spelling workbooks, perhaps).

Be sure to provide a means for storing mementos, both those that the kids want and those that you want. When you have containers that can be added to easily, these items are less likely to be damaged or lost and can be put away efficiently, before they become clutter.

caution Use extreme caution when discarding other people's belongings without their consent. You can do serious damage to their trust in you and create unpleasant memories that last a lifetime. (Hey Mom, remember my beloved green gym shoes that you threw away one day when I was at kindergarten? You don't? Well, I do!)

Coats and Footwear

These are classic "drop" items: Everyone barrels through the door, kicks off their shoes, and dumps their coats on the way to the bathroom, refrigerator, or TV. Trying to change this one is tough!

Your best chance at fly-by organization here is to provide tools that require no delicate movements. Big hooks that can catch a tossed coat are more likely to be used than hangers; bins that shoes can be thrown toward will have a higher success rate than a shelf or shoe rack; school bags have a better chance of making it into a large, kid-height cubby than onto a high or narrow shelf. If you find that you're able to use the system on your way to the bathroom after rushing home from work or errands, you'll know you've chosen a winner!

Books

Books are either primarily decorative or primarily functional, and the distinction affects how they are stored. If a book is intended mostly to beautify a space (such as a "coffee table book"), it should be displayed like a work of art. If it is to be used for reference or read for pleasure, it should be stored on a bookshelf with its kin.

You can organize your books any way you like: Alphabetical by author or title, grouped by subject or genre, even lined up on a shelf according to size or the main color on the spine! You can use any system you like, as long as you apply some sort of order.

If you have trouble weeding out books, join the club. I believe everyone has a tendency to collect or even hoard at least one category of items, and mine is books. I finally made major progress in letting go of fiction titles I'd already read when I realized that I was saving them not to read again, but to remember that I had already read them. I made a list and donated them to the library, and in the process realized that I had no need to buy books in the first place—I can borrow them from the library and add them to my "Books I've Read" list!

Purging reference books has also become much easier with the growth of the Internet. There are few books in my office now that are more convenient or more reliable than anything I can find online. In particular, I've gotten rid of dozens of health-related titles, since up-to-the-minute info is now available with a quick Google search.

Managing Your Unique Challenges

Think back to Chapters 1 and 2, where you learned about the many varying tolerance levels and priorities that each member of your family might have, as well as the many physical and emotional conditions that can affect a person's organizing abilities. It is crucial to take these factors into account as you continue organizing your home, putting new systems into place, and maintaining existing ones.

If you don't respect these differences, you will have a hard time gaining everyone's cooperation. After all, you're the one reading the book, so household organization is probably more of a priority for you than it is for them! The following sections discuss some common argument-inducers that you might encounter down the road.

Don't Touch My Stuff!

When one family member gets the organizing bug, the others might feel compelled to lock up their belongings for safe-keeping! Remember that no matter how strongly you believe your innovations will be better for everyone, the others are still entitled to some say in what is done with their things. It's always a bad idea to discard other people's stuff without their consent; even if someone tells you it's okay to weed out, say, their clothes, you should still give them the courtesy of double-checking anything that you aren't absolutely sure they no longer want or need.

You might also find yourself feeling protective over your freshly organized belongings and barking at the others to not mess them up. This is normal too; no one wants careless people trouncing on their progress. Just try not to be obnoxious about it.

Be More Careful!

I've always been very careful with my belongings, and as an only child, I had relatively few incidents of some other marauding kid breaking my stuff. I didn't have to share my toys and clothes with siblings, so I grew up knowing that their survival was my responsibility and that I had the power to ensure it. This might have actually worked against me, though: Now, as a grown-up, I have a hard time tolerating other people's clumsiness with my belongings. If anyone, adult or child, ruins something of mine out of carelessness, I seethe.

I've learned to avoid such incidents whenever possible. I dodge requests from friends to borrow clothes; I keep delicate things out of children's reach; I park far away from vehicles that look like they belong to door-bangers. I have resisted my mother's repeated urgings to take over her collection of crystal figurines because I just could not stand the heartache if one of the dogs slammed into the curio cabinet and...oh dear, I can't even finish that thought.

Remember, household systems should work for everyone in the household. Some areas and items can be off-limits to children or to anyone except their owner, but shared items must be organized in a way that is reasonable and realistic for all. If you've adopted organizational systems that seem to be too delicate for the rest of the family, don't fight a losing battle. Change the systems before irreparable damage is done to your stuff and your relationships.

You're So Wasteful!

This remark is a big flashing neon indication of differing priorities.

People have a number of reasons for getting organized, and one of them is often to prevent the waste of buying duplicates or having things spoil or expire because they weren't available to use in a timely manner. However, what seems like frugality to one person often looks like obsession to another.

Differences here will often crop up during the purging stage of organizing. One person wants to toss the slew of old margarine tubs and buy a dozen new Gladware containers, and the other sees this as a blatant waste of money. One wants to take the time to assign homes to every single object in the home without purging anything, and the other is infuriated at the waste of time this constitutes.

Remember that more than money is at stake here. The dollar (or cents) value of an item must be weighed against the cost, in money and in time, of storing and maintaining it. To store something properly, you might need to spend additional money on a good container. To have enough time to manage the belongings that really matter, you will likely have to take time away from the ones of lesser importance.

If you think one family member is wasteful (or if you're accused of it yourself), ask what the "wasteful" behavior might actually be saving. Is it saving time? Is it preventing more expense in the future? If so, it's not as wasteful as it might seem on the surface.

You Just Don't Think!

If you find yourself saying this to a family member more than once in a while, or if people say it to you a lot, you might be dealing with AD/HD or some other cognitive or physical cause of inattention or forgetfulness. Don't write it off as laziness or willful defiance: Get checked out by a doctor or other expert to rule out a condition that, without treatment, will have a negative impact on quality of life.

Remember, too, that your systems might be too complex or too nitpicky, or perhaps this whole organizing thing was thrust upon the family in a way that caused some or all of them to rebel. What you perceive as lack of thinking might be passive-aggressive resistance to your pet project. If you suspect this might be the problem, don't continue beating them over the head with what you want; try asking what *they* want and looking for ways to compromise.

You're So Picky!

There are other words for this, and if you've been accused of it, you know what they are. If you want everything just so and the others just don't care as much, you've probably acquired this label.

Remember the discussion in Chapter 2 about varying tolerances for visual clutter and general disorder. If you have a low tolerance for having things askew, you're not necessarily picky or compulsive or unreasonable. You might find home life easier if you can learn to relax a bit, though.

People who are labeled "control freaks" often behave this way, ironically, because they do not have as much control as they should. When areas of your life are negatively impacted by others and you can't make it stop (an overspending spouse, for example), you will tend to tighten the screws on the parts of your life that you can actually control. You might not be able to prevent him from coming home with a $2,000 entertainment system, but you sure as heck can nag him until he puts the cap back on the toothpaste.

The next time you're accused of being too picky, ask yourself if there is something bigger you'd really like to change if you could. Perhaps there's not; perhaps the point of contention is really no big deal. If so, see if you can let go a little bit and give everyone some breathing room.

Summary

Now you're armed with some ammunition to use if you encounter one of the many common organizing danger zones, and you've had a refresher in how to accommodate your and your family's unique needs. Let's move on to Chapter 10, "Managing Special Situations," and see what we can do about holidays, hobbies, houseguests, and a too-small home.

Managing Special Situations

Just when you think you've got everything
organized, some once-a-year-or-less event
comes along and throws a wrench in the
gears. It's inevitable that your beautiful new
systems, no matter how well-thought-out and
carefully implemented, will need to be adjusted
down the road. Your needs, priorities, and interests
will change, and your organizing systems must be
able to flex with them.

You've laid a strong foundation for the initial
phase of purging excess items and clearing out
the backlog of past disorganization, you've cre-
ated systems customized to your household, and
you've begun a maintenance program that will
keep it all running smoothly. In this chapter,
gather some tips for handling situations that you
might encounter someday which could interfere
with your home's organization.

To do list

- [] Organize items that are not in constant use
- [] Accommodate peaks and valleys in space needs
- [] Find sneaky ways to hide gifts to be given
- [] Store off-season clothes
- [] Avoid the pitfalls of stockpiling gifts to give
- [] Incorporate gifts you receive into your organized household

Holiday and Seasonal Space Needs

Organizing spaces in which the volume of items remains relatively constant is definitely easier than spaces that are sometimes crammed full and other times empty. But, fear not—you can successfully organize even these perpetually changing spaces.

The best way to do it also requires the most room or the most diligent pruning of belongings throughout the year. Simply put, the strategy is this: Plan each space for its fullest times, and when it's in a light phase, leave the space partially empty—don't fill it with other things.

Things You'll Need

- [] Storage tubs of various sizes.
- [] Gift-wrapping supplies.
- [] Containers and a system for making donations.

Rotating Seasonal Storage

Trying to keep everything you own in active storage—bedroom and linen closets, dressers, and the like—is probably a losing proposition for you. If you had plenty of space, you wouldn't be reading a book on organizing your home! The answer is to rotate items by season, keeping only those in current use in your active storage spaces and putting the rest away in the basement, attic, or even a rented storage facility.

Designate a storage tub for each family member (or more than one tub, if needed) and label it "[Name]'s Off-Season Clothes." Notice I didn't say "Winter Clothes" or "Summer Clothes"; the tub can serve both purposes alternately.

I keep my off-season clothes boxes near the washer and dryer, so it's easy to add to them. Think about it: Putting away your cold-weather clothes in one step would require that they all be clean, all at the same time. How likely is *that*?!? As off-season clothes cycle through the laundry in the spring and fall, I pluck them out of each load and add them to the storage tubs. If you don't have enough space near your washer and dryer for the tubs, just make sure you store them in a way that will be convenient to add to several more times before you're done for the season.

I recommend separating containers by person rather than by type of clothing (such as "Winter Coats"). When each person has his or her own box, it's easier to spot gaps ("Sissy needs a new winter coat by next year") or to differentiate items that have been outgrown in the interim ("Hah! This will never fit Junior now!").

Keeping Gift Storage Under Control

Here's another great reason to keep a few empty, all-purpose storage tubs around the house: They're handy for occasional gift-hiding! (This is one rare time when you do *not* want to label the container.) Just make sure the container will protect the item from being crushed, chewed by pets or pests, or damaged by heat or moisture.

GIFT-STORAGE NO-NOS

People can get really creative when it's time to hide gifts. Unfortunately, creativity and safety can sometimes clash. Here are some gift-hiding don'ts:

* The trunk of your car. It gets really hot in there, whether from the sun above or the car's exhaust below. If you get rear-ended, there go your gifts. You'll have no room for groceries in the meantime, and if a thief knows you have presents in the trunk, that's all the more incentive to steal your car.

* The stove. Even if your dearly beloved never cooks, this will be the one time he or she will be inspired to broil something, and who thinks to check the oven for flammables before using it? Ditto the clothes dryer.

* Above the panels of a drop ceiling. Two words: Mice, spiders.

* A "really safe place." Many of my clients are still trying to remember where their "really safe" places are.

If you like to maintain a stockpile of gifts for any occasion, be careful not to let it overwhelm your space. Buying the occasional item on impulse as a gift to give in a

few months can snowball into a basement full of various gifts with no particular intended recipient—shelf after shelf of stuff that will be great for someone, someday. Among the risks with this habit are

- The items will get dusty, old-looking, and possibly damaged by moisture or pests.

- Any warranties they have will run out, as will the window of time to return them to the store.

- Unless you keep a meticulous inventory and consult it every time you need a gift, you will forget what you have and just buy something else anyway.

- Precious storage space will be occupied by things that you never intended to linger for this long.

> **tip** If your kids (or even your spouse) are incurable snoops and might even try to peel open a wrapped present, trade storage space with a friend. It won't matter if your family sees the items; just make sure you tell them the gifts are for someone else. If you're concerned they'll be jealous of the other family's windfall or you don't want the kids getting suspicious of Santa's existence, ask a friend or relative with no young children to be your Storage Elf.

When people buy things because they would be perfect for so-and-so, it's often because they don't want to forget about the item. Instead of buying it right then and there and taking it home to store, let the *store* (or web-based vendor) store it for you! Add it to a list of gift ideas; take a picture of it with a camera phone or print it out if you're shopping online; or leave yourself a voicemail or email with the item's name, manufacturer, price, the store or website you found it in, and the name of the intended recipient. Then, closer to an actual gift-giving occasion for that person, consult your list and make a more informed buying decision, and keep your storage space available for more pressing needs.

Making Homes for Gifts You Receive

Remember way back in the beginning of this book, when you discovered the joys of purging? Well, you're not done. You will never be done, so long as new items continue coming into your life!

Whenever you receive something new, look around and consider what existing item you could now part with. What need does this new thing satisfy even better than something you already had? (If the old one is better, check the box for a gift receipt and return the gift for something you could really use!)

> **tip** It's a good idea to get children into this practice as early as you can. It keeps their belongings at a manageable level, a lesson that they will be very well-served to carry into adulthood, and it also fosters empathy for the world beyond their little universe-of-one: When they receive a gift and in turn donate something to charity, they are learning to literally "give back."

If the new item is not a natural replacement for an existing item, try to find something you could donate to balance the space now occupied by the new treasure. If you received a new coat and you don't have another coat that can now go, is there at least some other article of clothing you could part with? If not clothing, what about a few books, or something from the kitchen? It might not free up the same amount of space that the new item occupies, but you're still sticking to the tenet of something in, something out.

To do list

- ❑ Determine the reasons why your hobbies have taken over your home
- ❑ Streamline and make supplies and equipment portable
- ❑ Carve out time to actually enjoy your hobbies
- ❑ Make a plan for finishing projects in progress
- ❑ Create an "exit strategy" for completed works

Hobby Supplies and Equipment

Hobbies tend to take on a life of their own. It's unusual to find a person with a passion for just one hobby instead of several, and it must be even rarer (I've never seen it) to discover that that person's hobby has not been incorporated into all parts of his or her life.

You do indeed have to *make* time for hobbies; no one has plenty of time just sitting there waiting to be used for something. Children have more school responsibilities than ever before, from kindergarten all the way through college; adults have careers, families, and households to juggle; and even retirement brings new time commitments in the form of volunteering, babysitting the grandkids, and for many, unfortunately, the new "career" of coordinating appointments with one doctor after another.

If you still make time to pursue a hobby along with all of that, good for you!

Things You'll Need

- ❑ Containers for toting supplies outside your home.
- ❑ Supplies to organize hobby stuff in your home.
- ❑ A camera to record the projects you finish before you give them away or sell them.

When Hobbies Attack

People often get excited about a hobby and then lose interest in it in favor of a new one. This is especially common with hobbies that are similar: You might try crocheting and like it, then want to try knitting; while you're at the craft store, you see the gorgeous display of embroidery floss and decide to try that too. Pretty soon you get up the nerve to tackle sewing so you can make clothing for yourself or your kids. Then, one day at a flea market, you spot the most incredible weaving loom, big enough to make entire blankets and rugs, and your mind races: "Can this fit in the spare bedroom with the sewing machine; the craft table; the mannequin; the two armoires full of fabric and yarn; and the shelves of craft books, magazines, activity kits, and projects in progress? Nope, won't fit there, but I've been meaning to take over the family room anyway, and this is something we can all do together!"

You see how crafting can quickly overtake a home. Some examples I've seen of hobbies ruling the roost:

- A two-car garage lovingly protecting the husband's restoration vehicle, "in progress" for about 10 years, while his wife's brand-new car sits parked in the driveway.

- A family room dedicated to quilting, with piles of fabric, bags of stuffing, an overflowing armoire whose doors can't close, and in-progress and completed quilts lining the walls, even hanging in front of the television.

- Hundreds of skeins of yarn and hundreds more pattern collections, magazines, and books on knitting in a home office that already didn't have enough room for office materials.

- Entire bedrooms used exclusively as craft rooms in homes where the space was truly needed for more pressing activities, such as bill-paying.

Making Hobbies Manageable

So what can you do to rein in a hobby that's taking over your home? Here are some options:

- **Make it portable.** Even if you don't have a hobby that features organized social events, such as scrapbooking gatherings, if your hobby can be made portable, do it! Take it to the library, a friend's house, a park, a card table out in the yard—anything to give yourself a refreshing change of venue. In the process, you'll pare down your tools and supplies to the absolute essentials to facilitate your newfound mobility.

- **Give away your creations.** It's natural to want to keep and display every beautiful thing you make, but it's probably not realistic in terms of available

space. If you love art or crafting but you're pressed for square footage, make your treasures one at a time, as gifts or as prepaid, commissioned sales. Take digital photos of your best works.

- **Finish what you've started.** If you have many projects in progress, list them all and set priorities. Which are taking up the most space in their unfinished state? Which will be really useful when they're done (such as painting that room)? What are the reasons each remains unfinished? Figure out which of your projects could be completed with the least time and effort, and make time to work on it until it's done. Then immediately continue on with another one, and another, until they're done.

- **Examine your priorities.** Do some soul-searching about a hobby you haven't made time for in a while. If you're open to the idea, you might discover that this hobby is something you used to be excited about, but you've since moved on. If so, let it go: Donate the supplies to a person or group who will be as delighted with them as you once were. However, if the thought of never getting back to this hobby breaks your heart, do some slashing and burning in your schedule to make time for what's really important to you.

- **Get it organized!** Apply every organizing technique you've learned here to maximize your hobby space. If it's dominating areas that really are intended to be shared and the rest of the family does, truth be told, resent the hobby stuff, try to pull it back as much as you can and let that space go back to being communal property. If this idea makes you feel marginalized, find another space to claim as yours and yours alone. Wouldn't you rather it be a space that they won't complain about anyway?

> **tip** You can sell your creations, but selling requires a willing customer, which is harder to find than a willing gift recipient! Selling also usually requires making a quantity of items and then stockpiling them, which creates even more of a space problem, and it requires putting time into marketing or attending events such as craft fairs.

> **tip** If you get back into a project and find you're not enjoying it or you know it's not going to turn out right, abandon it. Don't make yourself do something you despise or that's going to make you feel like a failure. This is supposed to be fun, remember? If it's a remodeling project, hire someone else to finish it, move on with your life, and think twice before you take on a project like that in the future.

Things You'll Need

- ❏ Helpers to move furniture
- ❏ Shelves, drawers, and containers for the patient's room

Organizing for Guests and In-Home Medical Care

If you currently have a guest room, this is great news! Go do something better with it! A bedroom that's used just once in a while simply doesn't fit well with modern-day life. I hereby absolve you of the notion, a priority from an era now past, that whenever guests come to visit you, you're not a gracious host if you can't provide them with their own room and bed.

Kids and even grown-ups can sleep on couches or on an air mattress on the floor. If you have a sleeper sofa, that's a bonus. If you need to accommodate people who you know will not be happy with anything less than their own queen-size bed and private bathroom, rent them a room at a local motel and let them know what time you'll be around to pick them up for meals.

Extended in-home medical care is a different story. When you're caring for someone through a serious illness, particularly if you're providing hospice for someone who is dying, the patient's comfort is the top priority.

It can be difficult or impossible to predict how long such an arrangement is going to last. For that reason, it's better to plan for a long stay and have it end sooner than expected (hopefully due to recovery) than to treat the situation as very temporary and have it last for months or years.

Organizationally, the situation will be least disruptive if the person already had his or her own bedroom in your home. In that case, the regular bed can be removed and stored while the hospital bed is put in its place. Other furniture will likely need to be moved as well. If the room did not have a television, you'll probably want to add one. You will also need storage space (drawers and shelves) for supplies and medications; try to balance convenience with aesthetics by keeping only the most frequently used items out in sight.

Do not relocate the bed and other furniture to a spot that will cause disruption elsewhere in your home (for example, propped against the wall in the living room or out in the garage, making it unusable for parking). If it can't be stored out of the way somewhere in your home, rent a temporary storage facility and take it there. You're going to have enough disruption, not to mention emotional difficulty, during this time; don't make it harder on yourself by reducing your usable space any more than absolutely necessary.

If the person shared a bedroom with someone else in your home (perhaps yourself) or did not previously live with you, it will be more difficult to create the space you need. Whatever you do, make sure that everyone living in your home has a proper place to sleep. Don't allow anyone, yourself included, to be displaced to a couch or the floor for more than a few days.

Also take care to maintain some areas of your home for the family to unwind in relative normalcy. In addition to having a bed to sleep in, everyone needs somewhere

they can go in the home that is not impacted by the illness. It might be a basement rec room, a living room distant from the ill person's bedroom, a breakfast nook, a tinkering space in the garage, or even a bathroom with a tub for a nice long soak. If it was necessary to convert a bedroom or communal space into the ill person's room, do what you can to restore the functions of that space elsewhere in the home. For example, if it was the place where everyone watched TV, set up a television somewhere else for everyone to share, even if it's on a stand in the kitchen for now.

To do list

- ☐ Plan carefully how you will minimize disruption of household routines during the project
- ☐ Seal off the project area to prevent dust and debris from migrating into your living space
- ☐ Agree on the entrance and bathroom the contractors will use

Home Improvement and Remodeling Projects

I mentioned do-it-yourself projects in the earlier section on hobbies. This section is about large-scale projects—the kind that you hire contractors for.

You can get yourself into the time equivalent of a tar pit with do-it-yourself projects that never seem to end, but at least with those you do have control: You can get fed up and spend an entire coffee-fueled weekend finally getting it done. With contractors, you are at the mercy of their schedules, and let's just say that very few contractors could teach a class on good time management.

Things You'll Need

- ☐ A clear idea of your boundaries with contractors.
- ☐ Plastic sheeting and tape to contain the mess if your contractors don't do it themselves.
- ☐ Cleaning supplies for when the project is done.

Don't count on a remodeling project to end within a particular timeframe. Even if you agree on a deadline, even if you build financial consequences for lateness into the contract, don't bet on it being done on time. It's much less disruptive to settle in for a long process from the very beginning.

The key to survival for your household routines is to compartmentalize the remodeling as much as possible. Don't allow it to encroach on areas it doesn't have to. Hold

your contractors accountable for cleaning up as they go, and for keeping track of their tools and supplies. If they must leave things out from one day to the next, make sure they secure them within the workspace. Don't let them take over your garage or family room as a staging area for their work in yet another space: You're paying them—you don't owe them all the comforts of home.

Before the project starts, make sure the areas of your home that aren't included in the work are protected from it. Don't allow rooms outside of the work area to serve as storage for the things that will eventually go into the new space. How can you live a relatively normal, relatively efficient life if you're climbing over building supplies and excess furniture?

Also ensure that any mess made in the work-space will not migrate into the rest of your home. Be especially diligent with heavy plastic sheeting and tape, or even sheets of plywood nailed over doorways to seal off tasks that will generate drywall dust, sawdust, metal shavings, glass or tile particles, or anything else that you don't want to be perpetually cleaning off of every surface in your home. This will also keep children and pets from investigating the work area, then tracking dirt back into your home and even risking injury. Your contractor should do this for you, but if he or she doesn't, do it yourself—you will really regret it if you don't!

tip Never give construction crews the run of your house. If you find a contractor sitting at your dining room table, eating a sandwich and drinking your beer, you need to enforce some boundaries. Designate one entrance for them, as close to the workspace as possible. Designate one bathroom, or better yet, tell them to set up their own Porta-Potty.

tip Getting a new roof generates a lot of concussive force, from tearing off old shingles to dropping bundles on the roof to hammering each one in place, so you will end up with dust on absolutely everything, even if your home was clean to begin with. You won't be able to mask off the work area, so be prepared to clean every horizontal surface in your home, from the tops of picture frames to the entire floor of every room. For added safety, take down hanging pictures and remove breakables from shelves.

To do list

❑ Purge as much as you can before packing

❑ If you insist on having a garage sale, do it quickly and donate whatever doesn't sell

❑ Organize your packing plans

Preparing to Move

It's the worst-case-scenario of putting your stuff away: Packing to move. You have to put everything you own in some sort of container, take it somewhere else, and unpack it and put it away, hopefully before you have a desperate need for it again.

Things You'll Need

- ❑ Packing boxes and materials
- ❑ Markers for labeling boxes with their contents
- ❑ Colored stickers for indicating which room the boxes will go to in the new place
- ❑ Space to offload some items and containers out of the old place before the move
- ❑ An overnight bag for each family member
- ❑ Cleaning supplies for keeping your current home ready for showings

Organizing Before the Move

You have many opportunities to do this the (relatively) easy way rather than the hard way. Avoid creating more work for yourself with these pointers:

- Purge ruthlessly! Now is the best time ever to get rid of dead weight. Don't go to the trouble of packing, moving, and unpacking things that don't support you.

- If you're thinking of having a pre-move garage sale, be very sure that you have the time to do it along with all of your other moving preparations. And promise yourself that whatever doesn't sell will go straight to your favorite charity!

- Pack items according to their current homes. If you were diligent in creating homes for your belongings and you'll remember them according to those homes, pack them based on their current location. Examples: "Main Bathroom Vanity"; "Garage—Shelf Over Workbench"; "Under Kitchen Sink"; "Entertainment Center, Left Side"; "Laundry Room Cabinet."

- Pack in categories. Put like with like: things that logically go together. This makes sense for media (DVDs, CDs), books, tools, kitchen equipment, and toys. Avoid the dreaded "Misc." box!

- Try to fill each container so you're not "moving air," but don't compromise your categories to do so. Don't seal containers until your packing is almost complete so you can continue to add to them as you find items of the same category in odd places.

- Pack least-needed and least-used items first. This includes off-season clothes, sports gear, and yard equipment; holiday decorations; fiction books, games, and other recreational items; specialty kitchen items; and all but a handful of movies and music. These can remain boxed up at the bottom of the stack for a longer time than your frequently-needed items. Conversely, pack the majority of the kitchen and bathroom stuff last.

- Use double-thickness paper grocery bags to pack books. Even professional movers will gripe about the weight if you use large boxes for books. Fill the grocery bag halfway, then fold the top over and tape it. (If you suspect your movers won't be the gentlest ever, wrap the tape all the way around in both directions.) You'll end up with a bunch of brick-like packages that are easy to stack and of a manageable weight. Don't forget to label them!

- Don't take the time to write the room it goes to on each container. Instead, buy a package of various colored stickers and assign a color to each space in your new home. Then stick the right color on each box to designate where it will go. Hang a large paper with the corresponding color from the doorframe of each room before the move or as soon as you arrive on Moving Day.

> **tip** Label, label, label! Be specific. If this container ends up sitting in your new basement for a year, is "Kitchen" going to tell you everything you need to know about what's in it?

- Before completing your final packing as Moving Day approaches, have everyone pack a bag as if you were going away for a weekend: Include a few outfits, a few changes of underwear, grooming stuff, a few small entertainment items, any medications you take daily or think you might need, some nonperishable snacks, a small pillow, and your cellphone charger. Put someone in charge of carrying a couple days' worth of pet food, if needed. This way you won't be frantic to unpack everything the same day or even the next day.

> **tip** There's no need to buy expensive bubble wrap or cushioning material for packing breakable plates and bowls. Just use paper ones! Alternate one or two paper plates or bowls with each china dish. When you unpack, you can use the paper dishes for your first pizza night in your new home!

Moving and Selling at the Same Time

It's hard enough to pack up your things while still living in the space; the worst is when you have to welcome visitors at random intervals throughout the process! If you're moving out of a home you've put up for sale, you have the added challenge of keeping things looking neat while you prepare your family and all of your belongings for the move.

Offload as many boxes and excess items as possible before you open your home for showings. If you have the luxury of moving into your new place before the current one sells, consider yourself blessed and take advantage of the opportunity to move at least some of your belongings. (Talk to your real estate agent about the pluses and minuses of putting the house on the market unoccupied.) Otherwise, rent space in a storage facility for a month or two, or rent a container from PODS (Portable On-Demand Storage: www.pods.com) that can be set up in your driveway or in your yard to hold your stuff as you pack it and also to transport it to the new site.

To do list

- ❏ Make sure you've purged as much as you can
- ❏ Make the absolute best use of every square inch of space
- ❏ Replace big items with small wherever possible
- ❏ Replace single-function items with multi-taskers
- ❏ Put inessential items in temporary storage

When Your Home Really Is Too Small

You might say it all the time—"There is just *no room* in this place!"—but do you secretly wonder whether it would be adequate if you could just get organized?

If you've done your darnedest with all of the advice in the preceding chapters—purged and sorted and added containers and maximized vertical space and all the rest—and you still feel claustrophobic, you have a few questions to consider.

Things You'll Need

- ❏ Containers for organizing your belongings as cleverly as possible.
- ❏ Multi-use appliances and furniture.
- ❏ Creativity, perspective, and a positive attitude.

Do You Want to Live Here?

If so, are you willing to make still more compromises to make the space adequate? Perhaps it's a very small apartment in a very desirable area. Look again at your belongings. What else is not absolutely essential to your happiness and functioning? Would a smaller couch be better? Do you really need a dining table? What else can you do to give yourself more breathing room?

Think back to living with your parents. You probably had one bedroom where you kept all of your stuff. What strategies did you use to make that work? As much as it might irritate you to think you have to live like a dependent again, try to remember the tricks you used to make your stuff fit into one room, and modify them to help with your current quarters.

Combine functions whenever possible. A toaster oven can replace several appliances in the kitchen; one that's mounted under a cabinet saves counter space. A TV with built-in VHS and DVD players does the job of three separate components (four if the DVD player will also play music CDs). A futon can be both a couch and a bed. Voicemail eliminates the need for an answering machine, and a cellphone can replace the landline altogether. A laptop computer takes much less space than a desktop, and you can take it with you to a nice, big park or library when you feel the need for wide open spaces.

Is It Me, or Is It Really the Space?

If you're laboring with a home with just one closet, a kitchen with no counters, or a bathroom with no cabinets, blame the space. If the ceilings are too low and the rooms are too small, this space literally does not fit you.

Does each family member have a bed and at least part of a bedroom? Does each person have at least six feet of closet space or the equivalent in drawer space? Is there a seat for everyone at meal times and in front of the TV? Does everyone get enough bathroom time (by your rational definition, not their teenage one)? If someone has a home-based business, does it have its own room? If all of these criteria are met, the space isn't a complete loser.

If you could imagine someone else living here without discomfort, the problem lies with you. Not that there's anything wrong with you—your needs just aren't being met by this space. And sometimes simply identifying that can make it easier to live with until a better situation presents itself.

IS MY HOME REALLY TOO SMALL?

If you're trying to determine whether your home really is too small for you and your family, ask yourself these questions:

* Do I use everything in this space at least once a year?

* Have I eliminated single-function items in favor of multi-function?

* Do I have the bare minimum of towels, linens, shoes, jeans, and so on?

* Have I eliminated "showplace" spaces such as formal living rooms and guest bedrooms?

* Have I maximized vertical space?

* Have I maximized out-of-the-way storage such as the garage, basement, and attic?

* Do I stockpile no more than two weeks' worth of food and household supplies?

* Have I eliminated furniture that I don't truly need?

If you've done all of this and still don't have room for true necessities, the space really is too small for your needs.

Summary

With just one chapter to go, you're well-positioned to maintain your organization into the future. You have the tools to purge, create homes, develop new systems, modify existing ones, and maintain everything like a spinning merry-go-round. There's just one more point I want to emphasize before we wrap up: backsliding. Move on to Chapter 11 for your final home-organizing lesson.

Recovering from Backsliding

Before we wrap up your home-organizing odyssey, I have a few final words of encouragement on the most discouraging of all organizational pitfalls: backsliding.

Backsliding is what professional organizers call it when clients lose ground with their organizing progress. We might leave a client's kitchen looking like it belongs in *Better Homes & Gardens,* and come back a month later to find it in utter disarray. The client generally feels terrible about it, but the organizer simply surveys the scene and says, "Ah. Backsliding."

Backsliding can be minor or major, measured by the appearance of the space or by the amount of time it will take to bring it back to right. For you, the client, it's usually more devastating than the situation actually warrants, and that makes backsliding dangerous: The devastation you feel can easily convert to a feeling of being overwhelmed, which converts to paralysis, which leads you to close the door and ignore the problem when it is, in fact, still easily recoverable.

To do list

- ❑ See backsliding as the solvable problem that it is
- ❑ Learn to anticipate occasional bouts of backsliding as the normal consequence of a full life
- ❑ Avert panic: Backsliding is reversible!
- ❑ Create a plan to correct backsliding now, before it happens
- ❑ When you experience backsliding, put your recovery plan into action

The Facts on Backsliding

There are two irrefutable truths that I want you to carry with you from now on. These are

1. Backsliding is normal.
2. Backsliding is recoverable.

The following sections discuss these realities in more detail.

Backsliding Is Normal

Whoever said "Life happens" could have been talking about backsliding. Scientists would argue that backsliding is, in fact, natural. Their word for it is *entropy*, defined as "a gradual decline into disorder." When you maintain an organized home, you are in effect defying a major law of physics!

Backsliding is not failure. It doesn't mean your efforts to get organized were in vain. Keep in mind that "getting organized" is a process, not an event: There is often a larger amount of work at the beginning as you clear out a backlog of clutter and put new systems in place, but the maintenance that comes after that is also part of getting organized.

When you fall behind on maintenance, when entropy begins, you're experiencing backsliding.

Backsliding Is Recoverable

No matter how well it fits within the course of natural events, every person has the power to defy backsliding. The hardest part is getting past your fear that it's undefeatable.

It's a lot like learning to break cement blocks with your hands. Have you ever seen a martial arts display and wondered how they chop through those blocks without breaking bones? The answer is simple: Some technique, but mostly the belief that they can.

You start out practicing on a one-inch thick, 12-inch-square pine board. You whack at it with the side of your hand a few times, cause yourself some pain, watch other people going right through it, and your mind races to resolve the problem: Why can they do it and I can't? It's especially confounding when you're an adult and you're watching kids "Hi-yah!" their way through board after board.

You keep trying, and at some point you truly believe you can do it. Not hope you can, not wish you could, but honestly *know* that you are capable of putting your hand through the board in front of you and causing no injury to yourself. And once you believe it, your hand passes through the board and you literally do not feel a thing. It's as if the board's molecules parted an instant before yours arrived.

> **tip** The martial artists splitting cement blocks on TV started out with thin pine boards, and the people who remain constantly, dazzlingly organized started out intimidated by a week's worth of countertop clutter. You can become one of them with practice and perseverance.

Leave Yourself Some Bread Crumbs

Right now, having just finished the organizing you've accomplished as you worked through this book, your confidence is at an all-time high. You have tools, you have systems, you have strategies, and you believe that organization is achievable. There is no better time than right now to create a plan for recovering from backsliding when it does occur.

And it will. Remember, backsliding is not failure. It's not an indictment of your organizational abilities or the quality of your systems. It is the result of unexpected mishaps, crises, illnesses, accidents, interruptions, and breakdowns. It happens when you spend two weeks on overtime, when your spouse gets the flu, when your daughter gets engaged, when you end a relationship, when you take a trip, when your dog gets sick, when the furnace breaks. Remember the analogy of organizing maintenance as akin to pushing a merry-go-round? Backsliding is when that merry-go-round slows down because you had to turn your attention to something else for a while.

It is normal and recoverable, and it is inevitable, so leave yourself directions to get back to the merry-go-round *now*, while the way is clear in your mind.

Things You'll Need

☐ A notebook or computer to create your own "Back on Track" guidebook

Create Your Own "Back on Track" Guidebook

I've written you an entire book on organizing, and now I want you to write yourself one. It doesn't have to be anywhere near as long as mine—you might only need a few pages of pithy notes to yourself and page numbers from here to refer back to as needed.

Your guidebook should contain enough detail to remind you of the systems you've instituted in your home. You might not think so now, but you could forget, down the road, just what it was you intended to do in a given space. What was your logic for categorizing the way you did in the pantry? How did you decide which clothes to hang and which to fold? What's the fastest and most complete way to process the daily mail? How did you apply the eight fundamental principles from Chapter 3, "Principles to Live (and Organize) By," and throughout the book to your own organizing challenges?

Record your systems now, while they're fresh in your mind. If you wait until backsliding occurs, it will be much more difficult to recall what you need to do to get back on track. Writing your guidebook now is like leaving a time capsule for your future self to open in case of emergency!

Some people like to make checklists (for example, one for each room or task), while others prefer to write diary-style. Some make drawings, and others might simply copy over the points they highlighted in this book with a few words about how they applied them. Some prefer the speed and flexibility of creating their guidebook by computer instead of writing it by hand. Use whichever method or methods will work for you.

Keep your new guidebook in a file or container along with this book and any other notes you have created or collect about organizing. Add to your guidebook whenever you discover a great organizing product—note the manufacturer, size, price, and where you got it so you can get more as needed. Keep track of how your systems are operating, and what modifications you make to fine-tune them even more. You could even start a home inventory in your guidebook, listing all of your belongings for which you would need to make an insurance claim in the event of a disaster.

When life happens and backsliding occurs, consult your guidebook. Look up what you wrote about the affected area(s), and remind yourself that a) you do have a system, b) the system did work, and c) you already have notes or a checklist on the tweaking you need to do to get that system back on track. If you don't yet have an entry on the particular area that needs attention, read the rest of the guidebook to remind yourself of all the progress you've made throughout your home. Refresh your memory of the many systems you have in place for other areas, and use them to give yourself ideas for solving the problem at hand. Then start a new page and record your plan, and use it to get that backsliding corrected.

SET ARTIFICIAL DEADLINES

When your home is disorganized, you tend to avoid having people over, yet when a visit can't be avoided, you somehow find the energy to do some frantic tidying. Use this to your advantage! Trick yourself into staying clutter-free by scheduling a party, hiring a cleaning service, starting a book discussion group, inviting a date for dinner—anything that will force you to de-clutter before the event.

Summary

Congratulations on your organized home!

I hope you've enjoyed the process and are now reaping the rewards of efficiency in your clutter-free, optimally functioning environment. As you move on, remember that "organized" is not a destination but part of the journey; you will need to weed out belongings, reorganize spaces, and modify systems periodically, and keep up with maintenance all along the way. Hold to the eight organizing principles and you'll never stray far. Backsliding will inevitably occur, but you're well-prepared to handle it when it comes. Take your "Back on Track" guidebook with you and let it be your companion in organization in your current and future homes.

Conclusion

Wow! If you've worked your way through this entire book, you've accomplished a lot!

Let's review some key points to help cement them in your mind.

What Is "Organized"?

All you need to remember about "organized" is this: If it works for you, it works.

It doesn't matter if your space doesn't look like a Container Store advertisement.

If you have systems and you use them, and if those systems work for you and your family, you're organized!

Reasons for Disorganization

Disorganization can be caused or complicated by hundreds of factors, including health conditions, life circumstances, events, and differences in learning styles or visual processing. It can be tough to organize your home if you live alone, and it can be even tougher to organize a family's space in ways that work for everyone.

Organizing Is Cyclical

Organization is a state of existence, not a single event. When you "get organized," you reach a level of organization that satisfies your needs. From that point on, you must perform maintenance in order to stay organized.

It is natural for any system to erode if it's not used. It is also natural for any system to require changes over time. To maintain your organized life, you need to do two things perpetually: Use your systems and adapt them as needed. This means you'll have to "reorganize" spaces from time to time: Rearrange the pantry if you change your eating habits; condense space in one room to create space in another if a new family member joins your household; add more shelves or do some purging when your video collection outgrows its current home.

You will never be "done" organizing. If you keep it up, though, you'll never again have to dig through a huge backlog of clutter!

Old Habits Die Hard

As with any improvement you're trying to make, ineffective habits are often a major impediment to getting and staying organized. Once you identify the habits that are not serving you, you're halfway to your goal. You can change your habits, and you can encourage your family to do the same. If you're willing to keep trying until you see results, you'll get there eventually.

Backsliding Is Normal

Life will occasionally bring you challenges and interruptions that will temporarily send your organization off-track. This is part of the natural organizing cycle—don't let it give you added stress in the midst of a crisis. Once the situation has passed or at least stabilized temporarily, make it a priority to bring your organization back up to par.

Carry These Principles

As you continue your organizational accomplishments, improving existing systems and finding creative solutions for new situations and challenges, remember the eight fundamental organizing principles discussed throughout this book. These principles will support your organizing efforts for the rest of your life:

- Have a Home: Everything should have a home within your home—a place it belongs when it's put away (even if that doesn't happen very often). When you get into the habit of providing a home for everything, you will naturally begin to eliminate unnecessary items.

- Like with Like: Group things in whatever way makes sense: By function, by appearance, by owner, and so forth. When you put similar things together, it's easier to remember what goes where and how much you have, and it's easier to make comparisons and purge inferior items.

- Contain It: Containers protect your belongings, make them stackable and portable, and help keep like with like.

- Go Up: If you're pressed for space, you're more likely to find solutions near the ceiling than on the floor. Stack, shelve, and hang as much as you safely can.

- Be Systematic: Systems allow you to make "metadecisions," or one decision that covers a number of situations. Systems also allow you to create a set of guidelines and then just follow it without rethinking the process every time, preventing confusion, inconsistency, and arguments.

- Be Decisive: The single most important thing you can do to support your organizing efforts is to make decisions. Every day will bring you hundreds of decisions, and every one that you defer will just increase tomorrow's load. Clutter is the direct result of indecisiveness.

- Make Conscious Trade-offs: You can't have it all or do it all, so you will have to choose some things over others. Making these trade-offs consciously—"I don't need or have room for 15 black sweaters, so I'm keeping these 5 and donating these 10"— allows you to let go with less pain and to occasionally purge no-longer-needed items throughout your home.

- Get Organized Enough: "Organized enough" is all you need. Perfection is unattainable and pursuing it is no way to live. Organize your space so it's efficient and pleasant for you and your family; put systems in place that allow you to do what needs to be done; and as soon as you're organized enough, stop organizing!

If You Need More Help

If, after reading through this book and attempting to follow its guidance, you're still having trouble getting organized on your own, you have lots of options for help. A professional organizer can help you find solutions, and treating any underlying health issues will give you the energy and clarity to proceed on your own. If life circumstances or events are getting in your way, talking to a counselor can help you get past these issues and your emotions around them, allowing you to make mental space for organizing.

And here we are at the end! You've completed an important phase in your organizing journey, and I hope you've gathered much sustenance to carry with you into the future.

Wishing you an ideally organized life!

Part IV

Appendix

Further Resources

Following are resources mentioned in the book and suggestions for further research, arranged by subject.

Attention Deficit/ Hyperactivity Disorder

Books

Kolberg, Judith, and Kathleen Nadeau. *A.D.D.-Friendly Ways to Organize Your Life.* Brunner-Routledge, 2002.

Solden, Sari. *Women with Attention Deficit Disorder.* Underwood Books, 1995.

Websites

Children and Adults with Attention Deficit Disorder (CHADD): www.chadd.org

Offers support groups around the country for AD/HD adults as well as AD/HD kids and their parents.

Chronic Disorganization

Books

Glovinsky, Cindy. *Making Peace with the Things in Your Life: Why Your Papers, Books, Clothes, and Other Possessions Keep Overwhelming You—and What to Do About It.* St. Martin's Griffin, 2002.

Kolberg, Judith. *Conquering Chronic Disorganization.* Squall Press, 1999.

Websites

FlyLady: www.flylady.net

A positive, encouraging self-help site for those suffering from CHAOS (Can't Have Anyone Over Syndrome).

Messies Anonymous: www.messies.com

Founded by Sandra Felton, this group offers support and self-help options for "messies."

National Study Group on Chronic Disorganization: www.nsgcd.org

Offers resources for chronically disorganized people and the professional organizers who work with them.

Donation and Disposal

1-800-GOT-JUNK?: www.1800gotjunk.com

Ideal for pickup of large quantities of trash and heavy or unwieldy items. They'll even crawl into your attic or drag that old freezer up from the basement.

Brides Against Breast Cancer: www.makingmemories.org/babc.html

Donation resource for used wedding dresses.

Dress for Success: www.dressforsuccess.org

Donation resource for used business attire.

Earth 911: www.earth911.org

Information on earth-friendly options for disposal of various types of waste.

FreeCycle: www.freecycle.org

Resource for "recycling" unwanted items by offering them free of charge to members of your local community.

Gift of Sight: www.givethegiftofsight.org

Donation resource for used eyeglasses.

Glass Slipper Project: www.glassslipperproject.org

Donation resource for used prom dresses.

International Bicycle Fund: www.ibike.org/encouragement/youth.htm

Donation resource for used bicycles.

ItsDeductible: www.itsdeductible.com

Resource for determining the write-off value of items donated to charity.

National Cristina Foundation: www.cristina.org

Donation resource for used computers.

ReStore: www.habitat.org/env/restores.aspx

Donation resource for new and used building and remodeling materials and supplies.

Family Cooperation

Love and Logic: www.loveandlogic.com

Resource for fostering cooperation in children.

Feng Shui

Books

Collins, Terah Kathryn. *The Western Guide to Feng Shui.* Hay House, 1996.

Kingston, Karen. *Clear Your Clutter with Feng Shui.* Broadway Books, 1999.

Linn, Denise. *Feng Shui for the Soul: How to Create a Harmonious Environment That Will Nurture and Sustain You.* Hay House, 2000.

Websites

Western School of Feng Shui: www.wsfs.com

Resource for information on feng shui and referrals to practitioners.

Moving/Packing/Staging

Books

Allen, Jamie, and Kazz Regelman, eds. *How to Survive a Move.* Hundreds of Heads Books, 2005.

Matzke, Lori. *Home Staging: Creating Buyer-Friendly Rooms to Sell Your House.* Center Stage Home, 2004.

Websites

PODS: Portable On-Demand Storage: www.pods.com

Resource for packing and storing your belongings before moving.

Organizing

Books

Glovinsky, Cindy. *One Thing at a Time: 100 Simple Ways to Live Clutter-Free Every Day.* St. Martin's Griffin, 2004.

Lehmkuhl, Dorothy, and Dolores Cotter Lamping. *Organizing for the Creative Person.* Three Rivers Press, 1993.

Morgenstern, Julie. *Organizing from the Inside Out.* Henry Holt, 1998.

Websites

Easy Track: www.easytrack.com

Quality, do-it-yourself modular closet system.

Hold Everything: www.holdeverything.com

Resource for a variety of organizing products.

Lillian Vernon: www.lillianvernon.com

Resource for a variety of organizing products.

National Association of Professional Organizers: www.napo.net

Resource for information on professional organizing and automated referrals to local POs in the U.S. and internationally.

Professional Organizers in Canada: www.organizersincanada.com

Information and referrals for professional organizing in Canada.

Sauder: www.sauder.com

Quality ready-to-assemble furniture.

Sky-Rail: www.neatandniftystorage.com

A modular, clear container system that allows easy access to each "pod" in a stack.

Solutions: www.solutionscatalog.com

Resource for a variety of organizing products.

Stacks & Stacks: www.stacksandstacks.com

Resource for a variety of organizing products.

Paper Management

Books

Hemphill, Barbara. *Taming the Paper Tiger: Organizing the Paper in Your Life*. Dodd, Mead, 1988; revised edition, Kiplinger, 1997.

Vetter, Greg. *Find It in 5 Seconds*. Hara Publishing, 1999.

Procrastination

Books

Fiore, Neil. *The Now Habit*. Tarcher, 1989.

Sapadin, Linda. *It's About Time: The Six Styles of Procrastination and How to Overcome Them*. Penguin, 1996.

Time Management

Books

McGee-Cooper, Ann. *Time Management for Unmanageable People*. Bantam, 1994.

Morgenstern, Julie. *Making Work Work*. Simon & Schuster, 2004.

Morgenstern, Julie. *Time Management from the Inside Out*. Henry Holt, 2000.

Sgro, Valentina. *Organize Your Family's Schedule In No Time*. Que, 2004.

Index

D

How can we make this index more useful? Email us at indexes@quepublishing.com

T - U - V

W - X - Y - Z

How can we make this index more useful? Email us at indexes@quepublishing.com

Do Even More
...In No Time

Get ready to cross off those items on your to-do list! *In No Time* helps you tackle the projects that you don't think you have time to finish. With shopping lists and step-by-step instructions, these books get you working toward accomplishing your goals.

Check out these other *In No Time* books, available now!

Organize Your Personal Finances In No Time
ISBN: **0-7897-3179-7**
$16.95

Organize Your Office In No Time
ISBN: **0-7897-3218-1**
$16.95

Organize Your Work Day In No Time
ISBN: **0-7897-3333-1**
$16.95

Organize Your Garage In No Time
ISBN: **0-7897-3219-X**
$16.95

Organize Your Family's Schedule In No Time
ISBN: **0-7897-3220-3**
$16.95

Plan Your Walt Disney World Vacation In No Time
ISBN: **0-7897-3402-8**
$16.95

Looking for professional organizing assistance?

Contact the Organizing Authority!

The National Association of Professional Organizers

Whether you need to organize your business or your home, NAPO members are ready to help you meet the challenge.

A professional organizer enhances the lives of clients by designing systems and processes using organizing principles and through transferring organizing skills. A professional organizer also educates the public on organizing solutions and the resulting benefits.

NAPO currently has more than 3,300 members throughout the U.S. and around the world ready to serve you.

For More Information or to Find a Professional Organizer in Your Area,

Visit the NAPO Web Site at **www.NAPO.net**.